The Artist's Painting Library
LANDSCAPE DRAWING

BY WENDON BLAKE/DRAWINGS BY FERDINAND PETRIE

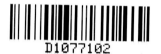

WATSON-GUPTILL PUBLICATIONS/NEW YORK

Copyright © 1981 by Billboard Ltd.

Published 1981 in the United States by Watson-Guptill Publications,
a division of Billboard Publications, Inc.,
1515 Broadway, New York, N.Y. 10036

Library of Congress Cataloging in Publication Data

Blake, Wendon.
 Landscape drawing.

 (The artist's painting library)
 Originally published as pt. 2 of the author's
The drawing book.
 1. Landscape drawing—Technique. I. Petrie,
Ferdinand, 1925– . II. Blake, Wendon. Drawing
book. III. Title. IV. Series: Blake, Wendon.
Artist's painting library.
NC795.B64 1981 743'.836 81-11523
ISBN 0-8230-2593-4 AACR2

Manufactured in Japan

First Printing, 1981

3 4 5 6 7 8 9/86 85

CONTENTS

Landscape Drawing. Strolling outdoors with a sketchbook under your arm and a few pencils in your pocket—that's an artist's idea of heaven on earth. To wander through the woods, climb a mountain path, or walk barefoot on the beach, absorbing the beauty of nature, is a joy in itself. But the pleasure of the outdoors becomes infinitely greater when you have the skill to record the beauty of nature on drawing paper. The tools and techniques of drawing are so simple, the process so rapid and spontaneous, that drawing is the ideal medium for capturing your emotional response to nature. A landscape drawing can be anything from a five-minute sketch of a single tree to a panoramic landscape of mountains that may take an hour or more. You can return from a morning's walk with several finished drawings or a dozen rapid sketches that may be lovely in themselves or may form the basis for paintings created in the studio.

Indoors or Outdoors. Although some people are outdoor artists and others are indoor artists, it's important to remember that the best landscapes always *start* outdoors, even if they're finished in the studio. The only way to learn how to draw a cliff or a cloud is to go out and find it. There's no substitute for firsthand knowledge of your subject. Working on location will strengthen your powers of observation and train your visual memory. So it's important to spend as much time as you can drawing outdoors, even if those drawings are nothing more than small, quick studies for bigger drawings or paintings which you hope to develop indoors. Those on-the-spot drawings—no matter how rough and crude they may turn out to be—will have a freshness and authenticity that you can get only by looking straight at the subject. If you decide to use these outdoor sketches as the basis for more work indoors, the *finished* drawing or painting will have a feeling of reality that you can never get by working just from memory or imagination.

Learning to See. The first few pages of *Landscape Drawing* are planned to train your powers of observation. You'll learn how to measure the height, width, and slope of various landscape elements, such as trees and rock formations. You'll learn how to judge the proportions of typical landscape forms such as boulders, trees, and clouds. The elements of linear and aerial perspective will be explained. And you'll learn how to judge values—the comparative lightness or darkness of your subject—so you can convert the colors of nature into the black-and-white tones of a drawing in pencil, chalk, or charcoal.

Starting with Basic Forms. Every contemporary landscape painter remembers Cézanne's famous observation that all the complex shapes of nature are based on a few simple geometric forms. So you'll learn how to visualize cubical forms as the basis for drawing landscape elements such as rocks and cliffs; cylindrical and conical forms as the basis of tree trunks and hills; rounded forms as the basis of boulders and masses of foliage. You'll also learn how to construct simple nongeometric forms as the basis for drawing objects with erratic shapes, such as a snow-covered tree or a mass of flying surf at the seashore. The noted artist Ferdinand Petrie draws a series of step-by-step demonstrations to show you the four fundamental stages in transforming cubical, cylindrical, rounded, and irregular shapes into typical forms of nature such as a rocky shore, a tree stump, trees, and windswept clouds.

Demonstrations. Petrie then shows you how to put all these techniques to work in a series of ten step-by-step demonstrations of complete landscape and coastal subjects: the rich texture and detail of trees; the intricate forms of a meadow with the broad shapes of hills in the distance; a stream winding among rocks and trees; a beach with the complex shapes of rocks; the rugged forms of mountains; the drama of surf crashing against a rocky shoreline; the soft, yet solid shapes of a snowy landscape; a shadowy pine forest; the still water of a pond surrounded by the diverse forms of the landscape; and finally, the rhythmic contours of sand dunes on a beach.

Drawing Media. These landscape demonstrations are organized according to medium, in three groupings: pencil, chalk, and charcoal. The demonstrations present a wide range of drawing techniques to show you the many ways of rendering contour, light and shade, texture, and detail in these versatile drawing media. Petrie's demonstrations show you how to render the forms of nature with various combinations of lines, strokes, and blended tones. Interspersed among the demonstrations are actual-size close-ups which show you many ways of rendering form with various types of pencil, chalk, and charcoal on different drawing papers.

Finding Your Own Way. These varied drawing tools, techniques, and surfaces are presented to help you find your own way. Fortunately, pencils, chalk, charcoal, and most drawing papers are inexpensive, so you're free to try as many alternatives as possible. Gradually, you'll discover which materials and methods seem most natural to you.

Keep It Simple. The best way to start drawing is to get yourself just two things: a pencil and a pad of white drawing paper about twice the size of the page you're now reading. An ordinary office pencil will do—but test it to make sure that you can make a pale gray line by gliding it lightly over the paper, and a rich black line by pressing a bit harder. If you'd like to buy something at the art-supply store, ask for an HB pencil, which is a good all-purpose drawing tool, plus a thicker, darker pencil for bolder work, usually marked 4B, 5B, or 6B. Your drawing pad should contain sturdy white paper with a very slight texture—not as smooth as typing paper. (Ask for cartridge paper in Britain.) To get started with chalk drawing, all you need is a black pastel pencil or a Conté pencil. And just two charcoal pencils will give you a good taste of charcoal drawing: get one marked "medium" and another marked "soft." You can use all these different types of pencils on the same drawing pad.

Pencils. When we talk about pencil drawing, we usually mean *graphite* pencil. This is usually a cylindrical stick of black, slightly slippery graphite surrounded by a thicker cylinder of wood. Artists' pencils are divided roughly into two groupings: soft and hard. A soft pencil will make a darker line than a hard pencil. Soft pencils are usually marked B, plus a number to indicate the degree of softness—3B is softer and blacker than 2B. Hard pencils are marked H and the numbers work the same way—3H is harder and makes a paler line than 2H. HB is considered an all-purpose pencil because it falls midway between hard and soft. Most artists use more soft pencils than hard pencils. When you're ready to experiment with a variety of pencils, buy a full range of soft ones from HB to 6B. You can also buy cylindrical graphite sticks in various thicknesses to fit into metal or plastic holders. And if you'd like to work with broad strokes, you can get rectangular graphite sticks about as long as your index finger.

Chalk. A black pastel pencil or Conté pencil is just a cylindrical stick of black chalk and, like the graphite pencil, it's surrounded by a cylinder of wood. But once you've tried chalk in pencil form, you should also get a rectangular black stick of hard pastel or Conté crayon. You may also want to buy cylindrical sticks of black chalk that fit into metal or plastic holders.

Charcoal. Charcoal pencils usually come in two forms. One form is a thin stick of charcoal surrounded by wood, like a graphite pencil. Another form is a stick of charcoal surrounded by a cylinder of paper that you can peel off in a narrow strip to expose fresh charcoal as the point wears down. When you want a complete "pal-ette" of charcoal pencils, get just three of them, marked "hard," "medium," and "soft." (Some manufacturers grade charcoal pencils HB through 6B, like graphite pencils; HB is the hardest and 6B is the softest.) You should also buy a few sticks of natural charcoal. You can get charcoal "leads" to fit into metal or plastic holders like those used for graphite and chalk.

Paper. You could easily spend your life doing wonderful drawings on ordinary white drawing paper, but you should try other kinds. Charcoal paper has a delicate, ribbed texture and a very hard surface that makes your stroke look rough and allows you to blend your strokes to create velvety tones. And you should try some *really* rough paper with a ragged, irregular "tooth" that makes your strokes look bold and granular. Ask your art-supply dealer to show you his roughest drawing papers. Buy a few sheets and try them out.

Erasers (Rubbers). For pencil drawing, the usual eraser is soft rubber, generally pink or white, which you can buy in a rectangular shape about the size of your thumb or in the form of a pencil, surrounded by a peel-off paper cylinder like a charcoal pencil. For chalk and charcoal drawing, the best eraser is kneaded rubber (or putty rubber), a gray square of very soft rubber that you can squeeze like clay to make any shape that's convenient. A thick, blocky soap eraser is useful for cleaning up the white areas of the drawing.

Odds and Ends. You also need a wooden drawing board to support your drawing pad—or perhaps a sheet of soft fiberboard to which you can tack loose sheets of paper. Get some single-edge razor blades or a sharp knife (preferably with a safe, retractable blade) for sharpening your drawing tools; a sandpaper pad (like a little book of sandpaper) for shaping your drawing tools; some pushpins or thumbtacks (drawing pins in Britain); a paper cylinder (as thick as your thumb) called a stomp, for blending tones; and a spray can of fixative, which is a very thin, virtually invisible varnish to keep your drawings from smudging.

Work Area. When you sit down to work, make sure that the light comes from your left if you're right-handed, and from your right if you're left-handed, so your hand won't cast a shadow on your drawing paper. A jar is a good place to store pencils, sharpened end up to protect the points. Store sticks of chalk or charcoal in a shallow box or in a plastic silverware tray with convenient compartments—which can be good for storing pencils too. To keep your erasers clean, store them apart from your drawing tools—in a separate little box or in a compartment of that plastic tray.

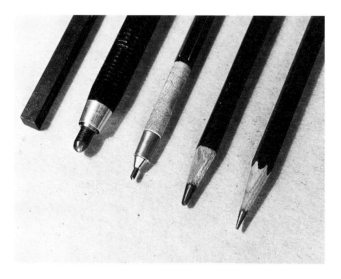

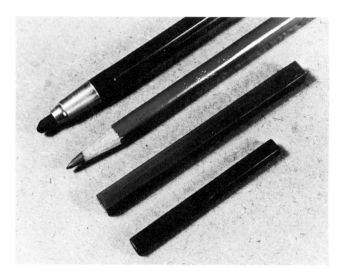

Pencils. The common graphite pencil comes in many forms. Looking from right to left, you see the all-purpose HB pencil; a thicker, softer pencil that makes a broader, blacker mark; a metal holder that grips a slender, cylindrical lead; a plastic holder that grips a thick lead; and finally a rectangular stick of graphite that makes a broad, bold mark on the paper. It's worthwhile to buy some pencils as well as two or three different types of holders to see which ones feel most comfortable in your hand.

Chalk. Shown here are four kinds of chalk. Looking from the lower right to the upper left, you see the small, rectangular Conté crayon; a larger, rectangular stick of hard pastel; hard pastel in the form of a pencil that's convenient for linear drawing; and a cylindrical stick of chalk in a metal holder. All these drawing tools are relatively inexpensive, and so it's a good idea to try each one to see which you like best.

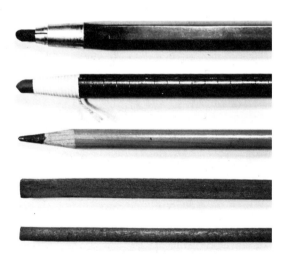

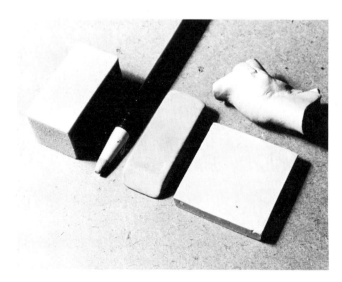

Charcoal. This versatile drawing medium comes in many forms. Looking up from the bottom of this photo, you see a cylindrical stick of natural charcoal; a rectangular stick of natural charcoal; a charcoal pencil; another kind of charcoal pencil—with paper that you gradually tear away as you wear down the point; and a cylindrical stick of charcoal in a metal holder. Natural charcoal smudges and erases easily, so it's good for broad tonal effects. A charcoal pencil makes firm lines and strokes, but the strokes don't blend as easily.

Erasers (Rubbers). From left to right, you see the common soap eraser, best for cleaning broad areas of bare paper; a harder, pink eraser in pencil form for making precise corrections on small areas of graphite-pencil drawings; a bigger pink eraser with wedge-shaped ends for making broader corrections; and a square of kneaded rubber (putty rubber) that's best for chalk and charcoal drawing. Kneaded rubber squashes like clay (as you see in the upper right) and can take any shape you want. Press the kneaded rubber down on the paper and pull away; scrub only when necessary.

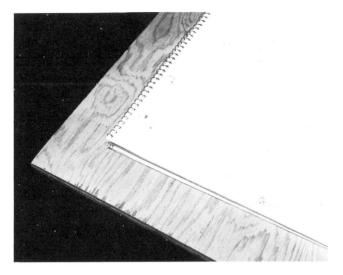

Drawing Board and Pad. Drawing paper generally comes in pads that are bound on one edge like a book. Most convenient is a spiral binding like the one you see here, since each page folds behind the others when you've finished a drawing. The pad won't be stiff enough to give you proper support by itself, so get a wooden drawing board from your art-supply store—or simply buy a piece of plywood or fiberboard. If you buy your drawing paper in sheets, rather than pads, buy a piece of soft fiberboard to which you can tack your paper.

Storage. Store your pencils, sticks of chalk, and sticks of charcoal with care—don't just toss them into a drawer where they'll rattle around and break. The compartments of a silverware container (usually made of plastic) provide good protection and allow you to organize your drawing tools into groups. Or you can simply collect long, shallow cardboard boxes—the kind that small gifts often come in.

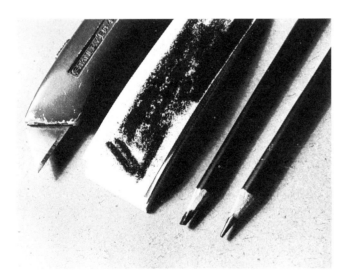

Knife and Sandpaper Pad. The pencil at the right has been shaped to a point with a mechanical pencil sharpener. The other pencil has been shaped to a broader point with a knife and sandpaper. The knife is used to cut away the wood without cutting away much of the lead. Then the pencil point is rubbed on the sandpaper to create a broad, flat tip. Buy a knife with a retractable blade that's safe to carry. To the right of the knife is a sandpaper pad that you can buy in most art-supply stores; it's like a small book, bound at one end so you can tear off the graphite-coated pages.

Stomps and Cleansing Tissue. To blend charcoal and push the blended tones into tight corners, you can buy stomps of various sizes in any good art-supply store. A stomp is made of tightly rolled paper with a tapered end and a sharp point. Use the tapered part for blending broad areas and the tip for blending small areas. A crumpled cleansing tissue can be used to dust off an unsatisfactory area of a drawing done in natural charcoal. (It's harder to dust off the mark of a charcoal pencil.) You can also use a tissue to spread a soft tone over a large area.

Contour Drawing. Like an athlete, an artist needs to warm up. One of the classic warm-up exercises is *contour drawing*. Choose a subject with big, interesting shapes—such as this tree stump. Let your eye move gradually around the edges of the shapes. Draw the contours with a sharply pointed pencil, letting the pencil rove across the paper as your eye roves over the subject. Try not to look at the paper too much, but keep your eye on the subject. Let your pencil "feel" its way over the paper as your eye "feels" its way around the shapes. Forget about details and draw only the big forms. Contour drawing teaches you to look at shapes carefully and draw them simply.

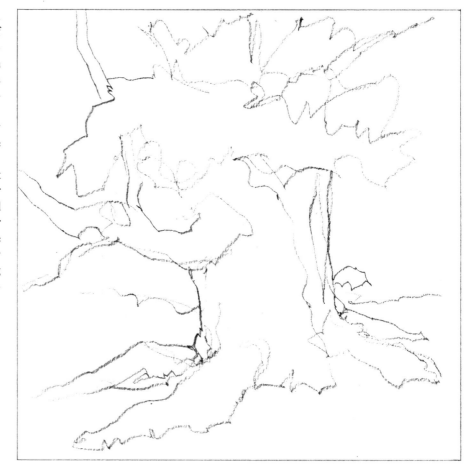

Groping Line. Now try another contour drawing with a thick pencil—or any pencil with a blunt point. Let your eye move very slowly around the shapes of the subject, while the pencil gropes its way slowly across the paper. Try to draw with the fewest possible lines, and do your best to keep your eye on the subject while you draw. Don't look at the paper too often. Don't worry if your line looks thick and clumsy. A thick line may not be elegant, but it's powerful and expressive. The value of this groping-line exercise is to make you slow down, look carefully, and capture essential shapes without fussing about details.

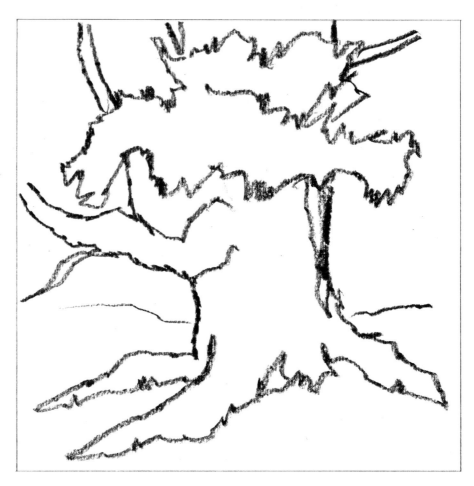

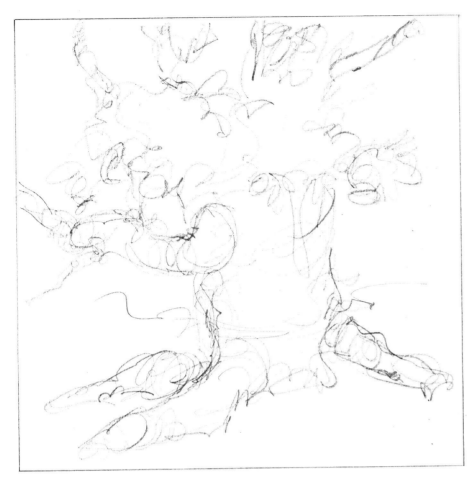

Scribbling. Now try a radically different warm-up exercise. Working again with a sharp pencil, let your eye wander over the subject while your hand scribbles round and round on the paper. Keep the pencil moving, whizzing back and forth, up and down, in zigzags and circles. You're not trying to trace the precise contours of each shape but trying to capture the subject's *overall shape* with rapid, intuitive movements. Your scribbled drawing will look messier than your other drawings, but the scribbles will have vitality and spontaneity—and that's what this warm-up exercise teaches you: to draw freely and spontaneously, trusting your intuition and "letting go."

Gesture Drawing. The subject doesn't actually move, but artists often talk about the *movement* of its forms. In reality, it's your *eye* that moves—rhythmically over the forms. The forms create a path for the eye, telling it where to go and communicating a *sense* of movement. This is what you try to capture in what artists call a *gesture drawing* Let your eye move quickly over and around the shapes of the subject while your pencil glides over the paper, as a skater glides on ice, imitating your quick, sweeping eye movements. This final warm-up exercise teaches you to look for the internal movements and rhythms of your subject—and then capture them with spontaneous lines.

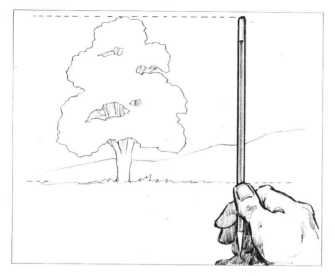

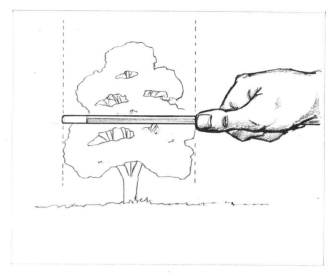

Measuring Height. Before you can draw any shape, you must be able to measure it. That is, you must know how its height relates to its width—and how its internal dimensions relate to its total shape. One tried-and-true method is to hold the pencil at arm's length in front of the subject, aligning the top of the pencil with the top of the shape, and sliding your thumb down the pencil to align with the bottom of the shape. (Be sure to hold the pencil absolutely vertical, and don't bend your elbow.) This gives you the overall height of the subject.

Measuring Width. Now, standing in exactly the same spot, turn your wrist so the pencil is horizontal. One end of the pencil should align with one side of the shape. Slide your thumb across the pencil until the tip of the thumb aligns with the other side of the shape. Now you have the width of your subject. Comparing the first measurement with the second, you see that the width is roughly three-quarters the height. (Another way to put it is that the tree is about four units high by three units wide.)

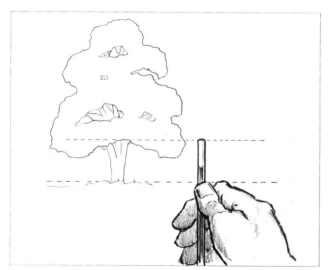

Measuring Internal Dimensions. Within the overall shape, there may be smaller shapes that you also want to measure—such as the trunk of this tree. Repeating the procedure for measuring height, you discover that the exposed section of the tree trunk is about one-quarter the total height of the tree (from the ground to the top of the leafy mass). At some point, you may be able to make measurements in your head—without the aid of thumb and pencil—but this method is a good way to start.

Measuring Slope. You can also measure diagonal shapes with a pencil. Hold the pencil so it lines up with the diagonal line of the form—such as this cone-shaped evergreen. With the angle of the pencil firmly fixed in your mind, turn your paper and quickly draw a diagonal line that matches the angle at which you were holding the pencil. Using the diagonal line as a guide, draw the zigzag shape of the tree right over it.

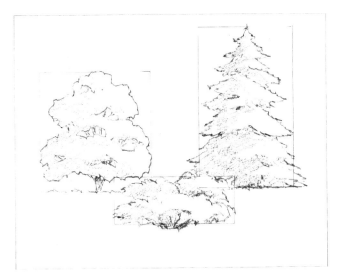

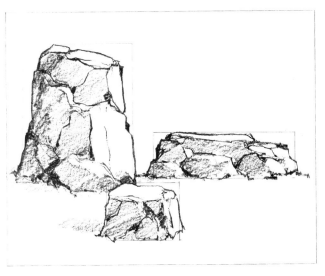

Trees. When you measure by the thumb-and-pencil method, you're really playing the game of fitting shapes into imaginary boxes. When the height and width of your subject are the same, it will fit easily into a square box; for example, the tree at the left fits into a box that's one unit high by one unit wide. The evergreen at the right fits into a box that's roughly two units high by one unit wide: its height is about twice its width. And the low shrub in the middle fits into a box that's about three units wide by one unit high: its width is three times its height.

Rocks. Blocky shapes like rocks are particularly easy to fit into imaginary boxes when you want to measure proportions. The tall rock at the left fits into a box that's four units high by three units wide: its width is three-quarters its height. The low rock formation at the right fits into a box that's about three units wide by one unit high: its width is three times its height. And the small rock in the center foreground fits into a box that's four units wide by three units high: its height is three-quarters its width.

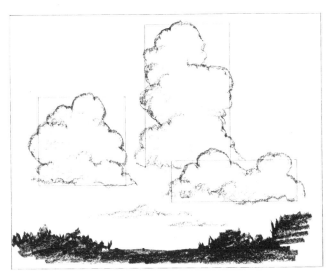

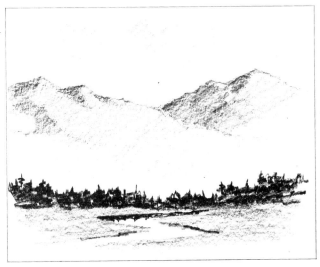

Clouds. Because clouds are big, soft, and puffy, you may think that it's harder to put their shapes into boxes. But the method is essentially the same. The cloud at the left fits into a squarish box, the tall cloud in the center fits into a box with a height roughly twice its width, and the low cloud at the right fits into a box with a width roughly three times its height. You can also use the thumb-and-pencil method to measure the internal shapes: the round puff at the top of the vertical cloud in the center is roughly one-quarter the cloud's total height.

Landscape. When you focus on a specific segment of the total landscape to draw your picture, you're drawing an imaginary box around that piece of landscape. Within the imaginary box, there are proportions that you can measure. The tops of the mountains are about one-third the distance from the top line of the box to the bottom line. And the dark line of the trees is about three-quarters of the way down. The line of trees is also about two-thirds of the way down from the tops of the mountains to the bottom line of the picture.

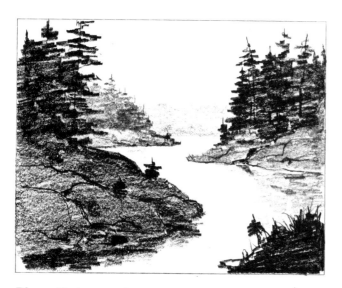

River. You've certainly observed the phenomenon called *linear perspective*. The parallel sides of streets, the parallel tracks of a railroad, and the parallel tops and bottoms of walls all seem to converge as they recede into the distance. Although the natural landscape has very few straight lines comparable to the lines of the man-made landscape, the rules of perspective still apply. The shoreline shown here is far from straight, but you have to remember linear perspective in order to draw the shape of this wandering stream.

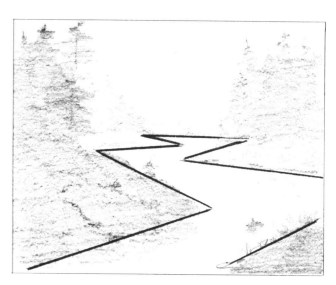

Perspective Diagram. The edges of the stream aren't exactly parallel, of course, but this diagram shows how the lines of the shore do seem to converge as they move back into the distance. No, this perspective diagram isn't mathematically perfect—nor is it meant to be. And you don't have to draw a neat, linear-perspective diagram every time you draw a stream or a path across a meadow. Just look at your subject carefully and try to imagine the perspective lines receding so your drawing will have a convincing sense of space.

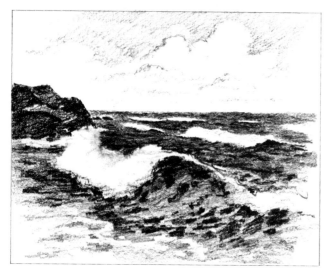

Waves and Clouds. Even a wave, with its rapid movement and curving shape, obeys the rules of linear perspective. At first glance, the imaginary perspective lines may be hard to visualize, but look at the diagram below to see how the lines work.

Perspective Diagram. If you draw imaginary lines across the tops and bottoms of the waves, you'll see that these lines seem to converge as they move toward the horizon. It's also interesting to note that the perspective lines in the foreground are distinctly diagonal, while the ones on the waves just below the horizon are more horizontal. And just as the waves look thinner and flatter as they approach the horizon, so do the clouds. The diagram shows that the clouds high in the sky are round and puffy but grow flatter toward the horizon.

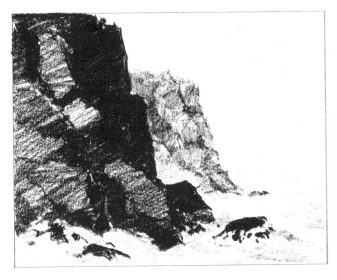

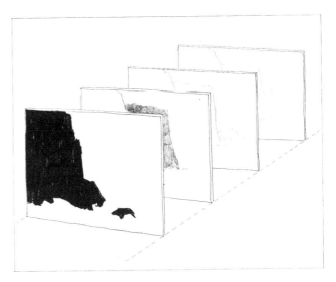

Headlands. There's another kind of perspective that's important when you draw landscapes. Aerial perspective is the tendency of objects to grow paler and less detailed as they recede into the distance. In this coastal scene, the nearest headland is darkest; it shows the strongest contrast between light and shadow; and it shows most clearly the details of the rocky shapes. The more distant headland—in the middleground—is paler, showing less contrast between light and shadow and less rocky detail. The remote headland on the right is simply a pale, gray shape with no contrast and no detail.

Perspective Diagram. It's often helpful to visualize your landscape as a series of planes or zones, as shown in this diagram. First there's the dark, distinct headland in the foreground. Then there's the paler headland in the middleground. Next, there's the very pale headland in the distance. And finally, the palest plane of all is the sky with its slight hint of clouds.

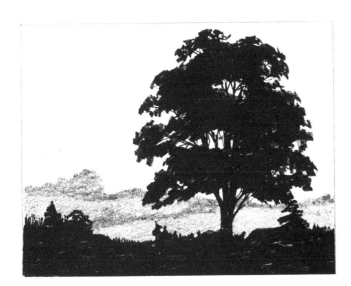

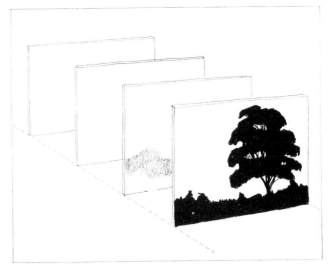

Trees and Hills. Here's another example of aerial perspective in a landscape. The tree and the grassy fields in the foreground are darkest, most distinct, and most detailed. The field and foliage in the middleground are paler, less distinct, and less detailed. The hill in the distance is simply a pale, gray shape. And the sky is bare white paper with a touch of pale cloud.

Perspective Diagram. This diagram shows the four planes or zones that appear in the landscape above. You can see the dark, precisely detailed foreground; the paler, less detailed middleground; the very pale, highly simplified hill in the distance; and the even paler sky. The four planes won't be so distinct in every landscape you draw, but always look for an opportunity to apply the rules of aerial perspective to give your landscapes a convincing feeling of space, atmosphere, and distance.

VALUES

Value Scale. Drawings are gener-
ally done in black-and-white media,
such as pencil, chalk, and charcoal.
This involves translating the colors of
nature into shades of gray, plus black
and white. These tones of black,
white, and gray are called *values*.
Theoretically, the number of values
in nature is infinite, but most artists
find it convenient to simplify nature
to about ten values: black, white, and
eight shades of gray. To fix this "pal-
ette" of tones firmly in your mind,
draw a series of boxes and fill them
with nine different tones, starting
with the palest possible gray and end-
ing with black. The tenth value, pure
white, is just the bare paper.

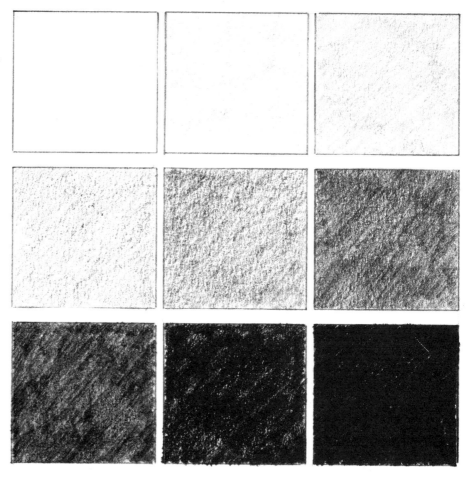

Selecting Values. With that so-
called value scale on paper and firmly
fixed in your mind, you're prepared
to translate the colors of nature into
the tones of pencil, chalk, or char-
coal. Pretending that your eye is a
camera loaded with black-and-white
film, look at your subject and decide
which colors become which tones on
the value scale. The deep evergreens
are likely to be a deep gray, just next
to black. The sky and the shadows on
the snow are the third or fourth tone
of gray. The frozen stream actually
contains two different tones of dark
gray. And the sunlit patches of snow
are white—which means bare paper.
As you can see, ten values are far
more than you need to make a con-
vincing picture. Just a few values
will do.

Three-Value System. Some artists feel that just three values are enough to make a good landscape—and they purposely simplify the values of nature to three tones. This coastal landscape consists of a very dark gray for the distant water, the grass at the top of the dune, and the dark reflection in the tide pool; a much paler gray for the dark strips of cloud in the sky and the shadow on the sand; and the bare white paper for the sunlit edges of the clouds and the sunlit patches on the sand. Look back at the value scale and see which tones the artist has selected.

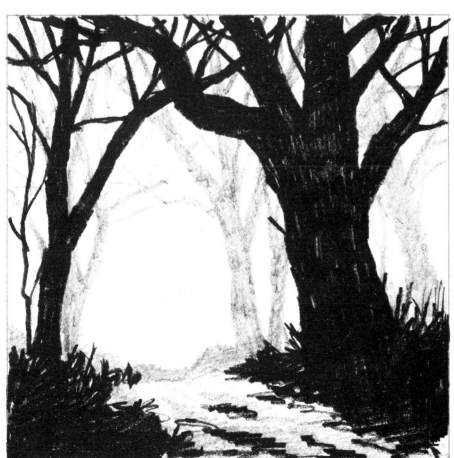

Four-Value System. Other artists feel that four values are simple enough and allow more flexibility. Here, the distant sky is bare white paper; the remote hill is a pale gray; the trees at the far edge of the forest are a darker gray; and the trees and grass in the foreground are the darkest gray—almost black. Again, glance back at the value scale and see which tones the artist has chosen from his mental "palette."

High Contrast. When studying your subject and choosing your tones from the value scale, it's important to decide how much contrast you see between the tones of nature. On a sunny day, you'll see a high-contrast picture. That is, you'll see bright whites, dark grays or blacks, plus various shades of gray between the two extremes. Another way to put it is that the subject gives you a *full range of values*.

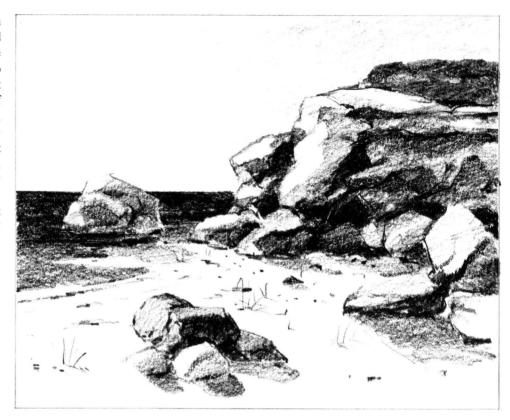

Low Contrast. On an overcast day, with the sun concealed behind a gray cloud layer, the same subject will present a much more *limited value range*. The light areas of the picture aren't nearly as bright, and the darks aren't nearly as dark. The whole picture consists of grays: a pale gray for the lightest areas, a not-too-dark gray for the darkest areas, and a couple of medium grays in between. Looking back at the value scale, you'll see that the tones of a high-contrast picture are widely scattered on the scale, while the tones of a low-contrast picture are close together on the scale.

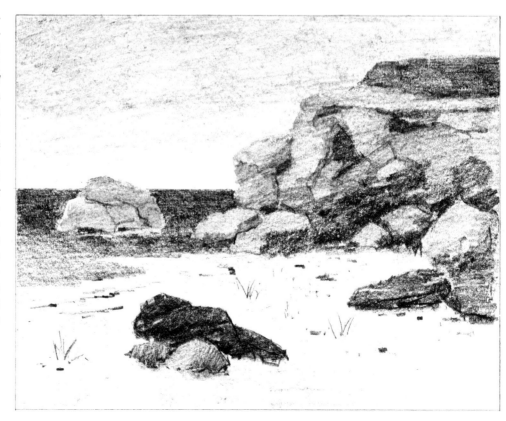

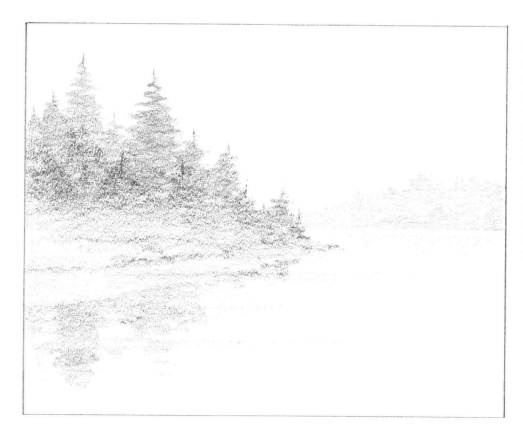

High Key. Artists also talk about the *key* of the landscape. When the overall tone of the landscape is generally pale, it's called a *high-key* picture. In this case, the values are apt to come from the beginning of the value scale—pale grays and possibly white. Even the darkest tones in the picture—the trees on the shoreline at the left—are relatively pale. Foggy coastlines and misty landscapes are often in a high key.

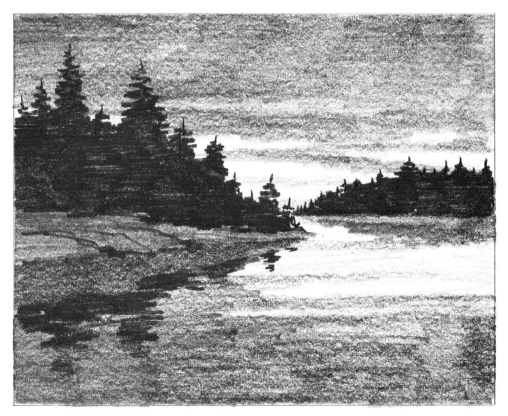

Low Key. In contrast with a high-key subject, a *low-key* picture is predominantly dark, drawing most of its values from the dark end of the scale. A change in light or weather can convert the same subject from a high key to a low one, as you see here. Now the trees are a deep gray (almost black) and the lighter tones of the sky, water, and shore are still fairly dark. Only the strips of light in the sky and water come from the light end of the value scale. It's interesting to note that the high-key picture above is a low-contrast subject, while this low-key landscape has higher contrast.

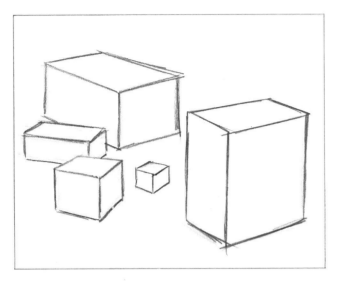

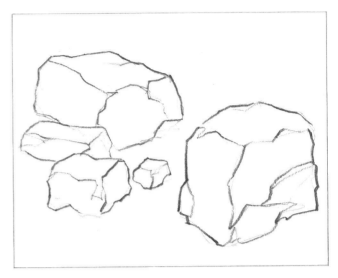

Cubes. Geometric forms are the basis of many shapes in nature, so it pays to practice drawing cubes and other blocky shapes. You can collect a variety of boxes around the house, scatter them on top of a table, and draw them from various angles. Start out drawing them with pencil lines. Keep your pencil sharp and don't hesitate to go over the lines several times until they're accurate. Don't use a ruler, but draw freehand. The lines don't have to be perfect.

Rocks. If you can draw those boxy shapes with reasonable accuracy, you can easily draw the blocky forms of rocks, which have top and side planes just like boxes—although the planes of the rocks will certainly be more irregular. You can begin to draw each rock by drawing a box (like those at the left) and then going back over the straight lines to transform the shapes into rocks. As you've already learned, it's also easier to visualize *proportions* if you start out with imaginary boxes.

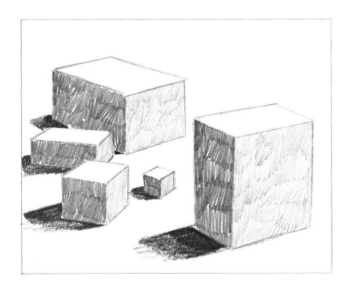

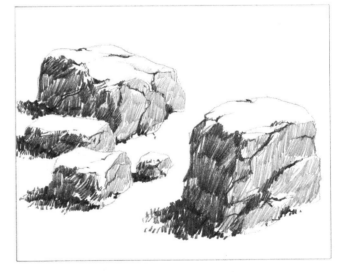

Cubes in Light and Shade. When you've had enough practice drawing boxes with pencil lines, render the tones on the top and side planes of the boxes with the side of the pencil lead. Generally, you'll find that each plane of the box has its own value. In this case, the top plane catches the light and is the palest value; one side plane is a light gray halftone (or middletone); and another side plane is a darker gray, representing the shadow side of the block. The block also casts a shadow on the tabletop—darkest right next to the block and gradually growing paler as the shadow moves away.

Rocks in Light and Shade. Keep these three planes in mind when you draw the values on real rocks. The planes won't be neat—nor will they be quite so obvious—but look carefully and you'll find them. In these rocks, as in the boxes at your left, the top plane is the light, one side plane is the halftone (or middletone), and another side plane is the shadow. The order of these planes *can* change when the light comes from a different direction: when the sun is low in the sky, one side plane could become the light and the other two planes, the halftone and shadow.

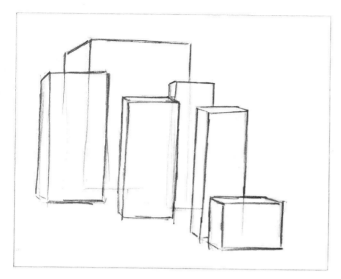

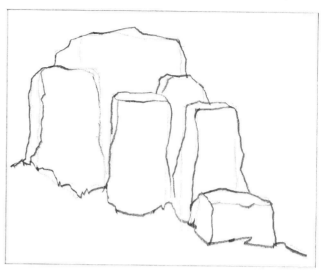

Oblongs. Imagine cubes sliced into pieces of various shapes and you have a number of oblongs. If you can find several long, slender boxes around the house, draw them just as you drew the cubical shapes on the previous page. It's helpful to draw these boxes as if they were made of glass, so you can see through them to the boxes behind. Draw the whole box, even if part of it is concealed by the box in front.

Cliff. Lofty rock formations, such as cliffs, often look like collections of oblongs. When you draw these natural shapes, keep those tall, slender boxes in mind. In fact, you can actually begin by drawing the shapes of the cliff as a series of oblongs, then go over the guidelines with more irregular lines that capture the rocky character of the subject.

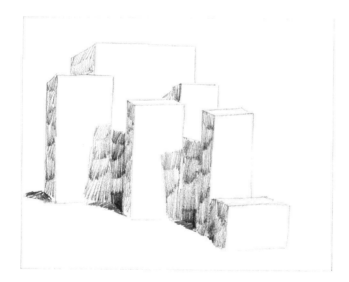

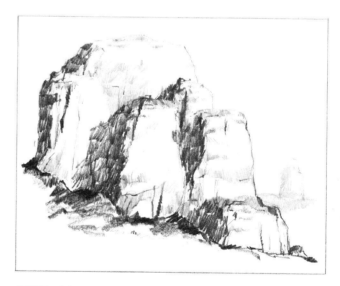

Oblongs in Light and Shade. Use the side of your pencil to block in the tones on the three planes of those tall boxes, and pay particular attention to the shadows that the boxes cast on one another. The light strikes the boxes from the front, so the frontal planes are the lightest value, the top planes are the halftones (or the middletones), and the side planes are the shadows. The cast shadows aren't a solid, even tone, but contain some reflected light picked up from a secondary light source, such as a distant window at the left.

Cliff in Light and Shade. The same tonal pattern appears on the cliffs, which are essentially oblongs. Of course, the planes of light, halftone, and shadow aren't as neat on these rugged rocks, but you can still see them clearly. Notice that the cast shadows contain a hint of reflected light picked up from the sky.

Step 1. When you go outdoors to draw, look for natural forms to which you can apply what you've learned about drawing cubical shapes. In the first few lines of his drawing of a rocky headland, the artist visualizes the subject as a huge cube with a slanted top plane. The smaller rock at the extreme right is also a kind of cube with slanted sides. And the foreground rocks are slices of cubes. These first few pencil lines are simply guidelines over which the actual shapes of the headland and rocks will be drawn more precisely.

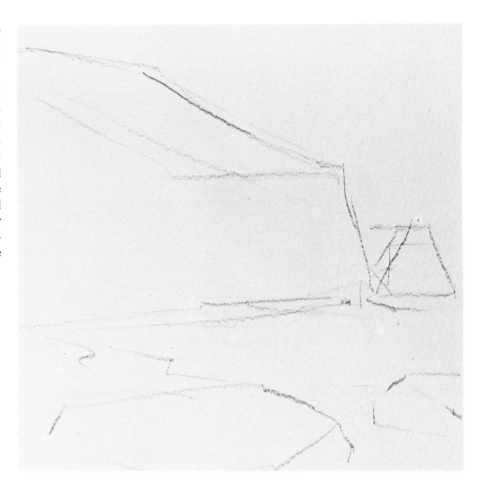

Step 2. Going back over the pale guidelines with firmer, darker strokes of the pencil, the artist draws the realistic contours of the headland and rocks. He looks for the erratic turns and breaks in the contours—the irregularities that make the shapes look more rocky. But he doesn't erase the original guidelines just yet, keeping in mind the simplified geometric forms that he drew in Step 1.

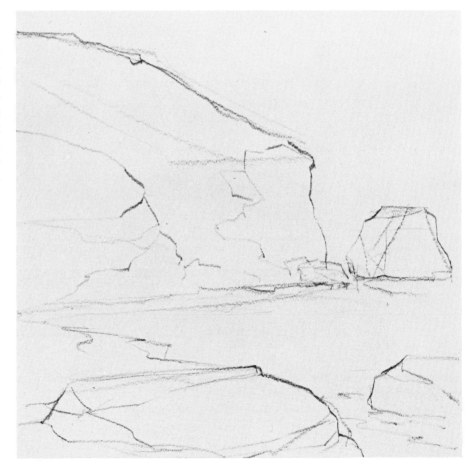

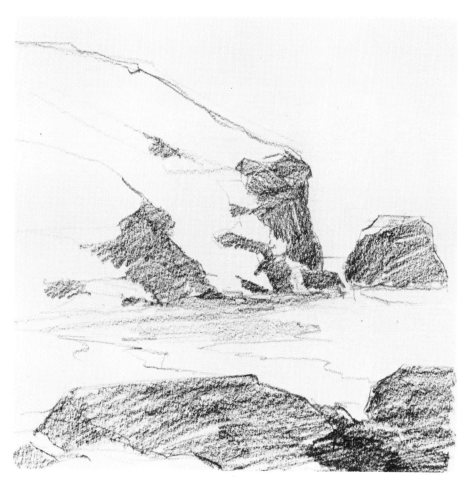

Step 3. Working with the side of the pencil, the artist blocks in the shapes of the shadows with broad, rough strokes. Now the big headland is clearly divided into planes of light and shadow, with the brightest light falling on the top plane. The rock to the right of the headland also has a lighted top plane and a shadowy side plane. The foreground rocks don't seem to receive as much direct light from the sun, so their top planes are darker than that of the headland, while the side plane (suggested in the lower right) is darker still.

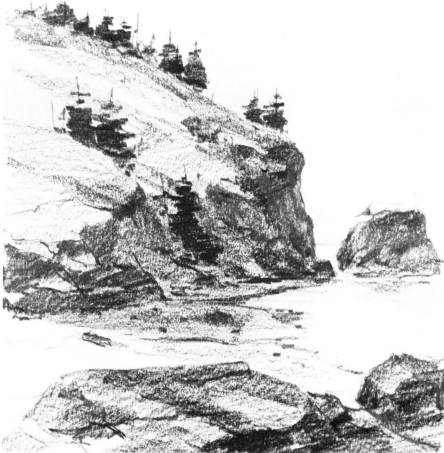

Step 4. Continuing to work with the side of the pencil, the artist adds the middletones (or halftones)—those values which fall between the lights and shadows—reinforcing the blocky shapes of the cliff and rocks. He also darkens the shadowy side planes of the rocks, emphasizing their blocky shapes. So far, the artist has concentrated on the big shapes of light, shadow, and halftone that make the shapes look solid and three-dimensional. Now he finishes the drawing by adding the cracks and other details within the rocks, plus the trees and the shoreline.

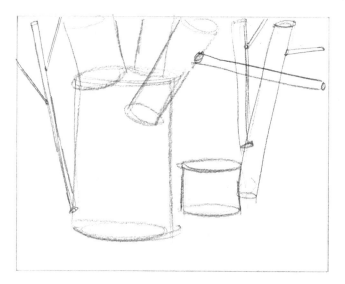

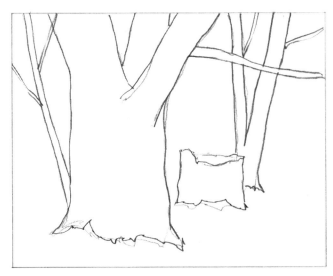

Cylinders. In outdoor subjects, cylindrical shapes are just as common as blocky shapes. Trees and branches are essentially cylindrical, although the simple geometric shapes may be concealed under the distracting detail of foliage and bark. When you look at a group of trees, try to visualize the trunks and branches as a collection of cylinders, some upright, some slanted and some horizontal. In fact, it's helpful to draw these cylinders with pencil lines.

Tree Trunks. When you've drawn these cylinders, you have convenient guidelines over which you can draw the actual shapes of the living trees with sharper, darker pencil lines. Now you can look for the irregularities in the contours—the bumps and dips that make the shapes of the trees and branches look real. But don't forget that the shapes are still basically cylindrical.

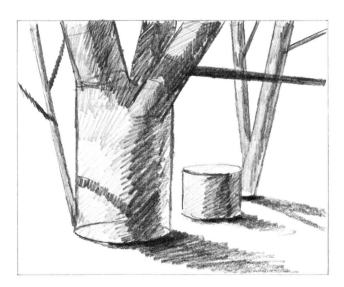

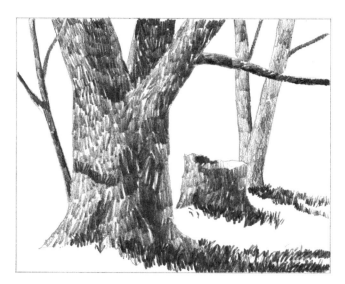

Cylinders in Light and Shade. In contrast with cubical shapes—where there are distinct planes of light, halftone, and shadow—the tones all run together on a cylinder. From left to right on the cylindrical shapes in this picture, you can see the gradual transition from the lighted left side of the tree to the halftone (or middletone) to the shadow to the reflected light within the shadow. (In outdoor subjects, shadows often contain light reflected from the distant sky or bounced off the mirrorlike surface of nearby water.) These cylindrical shapes cast curving shadows on one another.

Tree Trunks in Light and Shade. When you render the gradations of light, halftone (or middletone), shadow, and reflected light on tree trunks and branches, remember how the light wraps around a geometric cylinder. Don't be distracted by the texture of the bark. You can draw the bark with small, distinct strokes that convey the texture—but press harder on the pencil as you move from light to shadow, then make the strokes lighter as the shadow curves around to pick up the reflected light. The cast shadow on the ground is broken up by the grass, but you can draw this shadow with small ''grassy'' strokes.

Cones. A cone is closely related to a cylinder in the sense that both have curving sides—but the sides of the cone taper, while the sides of the cylinder remain roughly parallel. Practice drawing cones. Imagine that they're made of glass so you can see one behind the other—and so you can draw their elliptical bottoms. In this way, you get into the habit of visualizing cones as solid, three-dimensional forms. Ellipses are particularly hard to draw, so swing your arm with free, rhythmic movements, and don't hesitate to keep going over the lines.

Dunes. Sand dunes—like hills—are often flattened cones with irregular sides. When you draw sand dunes, remember their basic geometric shape even if that shape seems to disappear under the realistic contours of the sand. You can actually begin by drawing geometric cones and then draw the dunes over them. Or you can draw the dunes directly and keep the cones in your head.

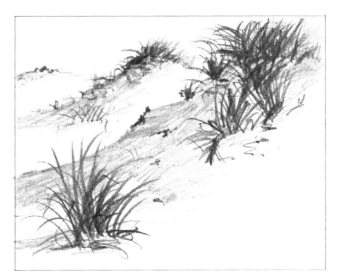

Cones in Light and Shade. Light, halftone (or middletone), and shadow wrap around cones very much as they do around the curving sides of cylinders. Those gradations can be subtle, so observe them carefully. On the dark side of the nearest flattened cone in this illustration, notice how the strokes become slightly denser to indicate the change from halftone to shadow—and then the strokes become more open to suggest reflected light at the left.

Dunes in Light and Shade. When you render the pattern of light and shade on the actual dune, remember the behavior of the tones on the geometric cones. Like the imaginary cones at left, the conelike shapes of the dunes pick up the sunlight on their right-hand sides and then curve gradually around into halftone and shadow. There isn't always a neat gradation from light to halftone to shadow to reflected light. In this case, reflected light appears throughout the shadow. The artist leaves some spaces between pencil strokes to suggest reflected light from the sky.

Step 1. An "outdoor still life," such as these two tree stumps, offers a good chance to draw cylindrical forms in nature. The artist begins by visualizing the stumps as short, thick, tilted cylinders with elliptical tops. The root at the left is a slender, tapered cylinder, something like a cone. The sharpened point of the pencil moves lightly over the paper so that these guidelines can be erased at a later stage in the drawing.

Step 2. Using the cylindrical shapes of Step 1 as a guide, the artist looks carefully at his subject and draws the ragged contours of the weathered wood over the pale lines. He doesn't follow the original guidelines *too* faithfully, but departs from them freely to create a more realistic drawing of the two stumps. He draws the jagged, broken tops of the stumps right over the elliptical guidelines—but he remembers that the ellipses are there. The root at the left no longer looks very cylindrical or conical, but the artist will remember the geometric form when he adds tone to the root.

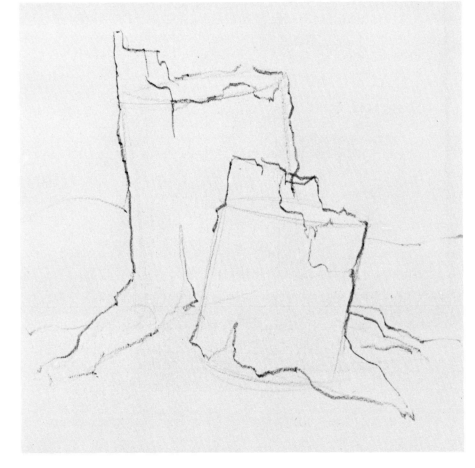

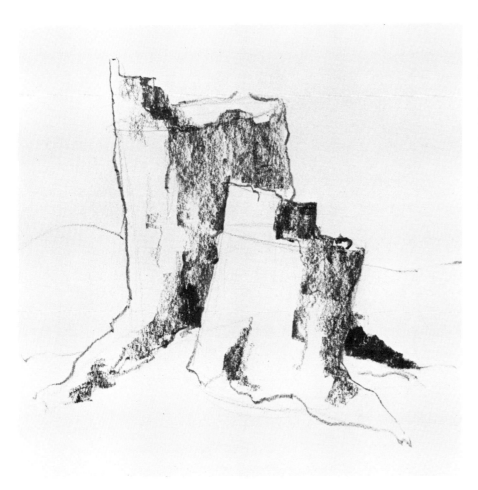

Step 3. Working with the side of the pencil, the artist carries broad strokes down the stump to establish the big shapes of the darks. Now there's a clear distinction between the light and shade on each large cylinder, as well as on the root at the left. At the tops of the stumps, strong darks are placed with the ragged shapes as they turn away from the light. A single root at the right is entirely in shadow, so this tone is blocked in.

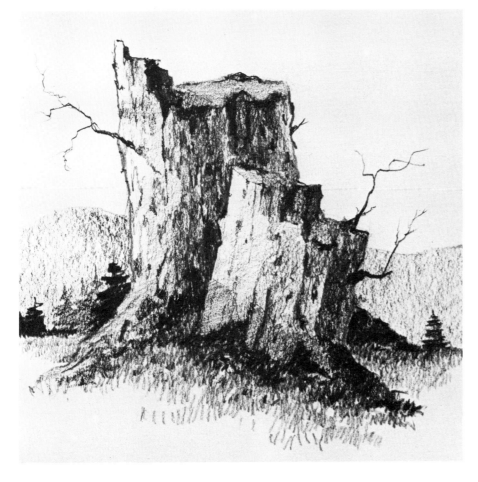

Step 4. Pressing harder on the side of the pencil, the artist darkens the tones on the cylindrical stumps to make the shapes look three-dimensional. Although the tones are interrupted by the broken texture of the weathered wood, the strokes suggest the gradual right-to-left gradation: light, halftone (or middletone), shadow, and reflected light within the shadow. The darkest shadows are placed within the cracks and where the stumps overlap. The artist's final step is to draw small details, such as the twigs and cracks, which come *after* he's rendered the gradation of light and shade that makes the subject look solid.

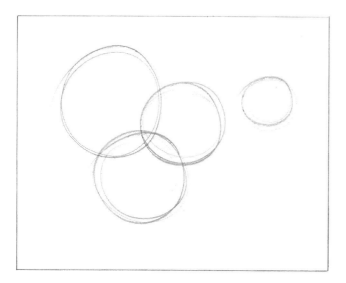

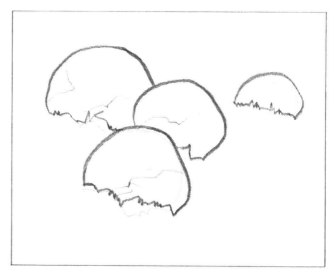

Spheres. Another basic geometric form that occurs constantly in nature is the sphere. Although there aren't many *perfect* circles in nature, practice drawing circles with the point of your pencil. The secret of drawing a really round circle is to swing your whole arm, starting from the shoulder, not from the wrist or elbow. Keep repeating that circular movement, going around and around, going over each circle again and again until the shape seems right. Your circles won't be geometrically perfect, but practice will make them round and full, which is what matters.

Rounded Rocks. Boulders are often irregular spheres, flattened here and there, and partly buried in grass or dirt. Once you've learned how to draw a circle with quick, rhythmic movements, you can draw circular guidelines and then build realistic boulders over these round shapes. Or you can go directly to work drawing the irregular contours of the boulders themselves.

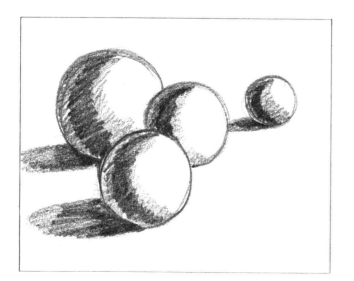

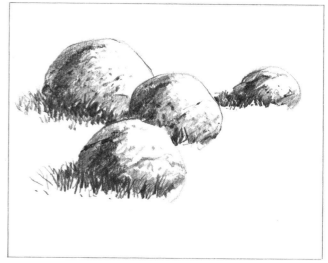

Spheres in Light and Shade. A sphere, like a cylinder, is a rounded form, so the tones wrap softly around the sphere and seem to flow together. Rendering the gradations of light and shade on a sphere takes practice. Put a tennis ball—or any kind of pale ball—near a window so that it receives strong light, and then practice rendering the tones with broad strokes, made with the side of the pencil. Exaggerate the areas of light, halftone (or middletone), shadow, and reflected light, as you see here, so they remain firmly fixed in your memory.

Rounded Rocks in Light and Shade. When you draw real boulders scattered in a grassy field, the rocky textures will be rough and irregular, making the gradation of light and shade harder to see. Render the tones with rough, irregular strokes, but vary the strokes so that they're lighter or darker to match the tonal areas you've seen on the tennis balls. Like the geometrically perfect balls at the left, these boulders are lit from the right, so there's a right-to-left gradation of tone from light to halftone to shadow to reflected light.

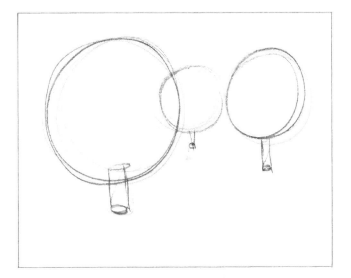

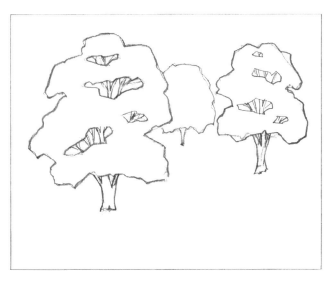

Spheres (Plus Cylinders). Trees and shrubs rarely look exactly like spheres, but it's often helpful to visualize them as spherical forms, just as it's helpful to visualize their trunks as cylinders. If the mass of foliage looks as if it would fit into a circle, you can begin with a circular guideline and then chop holes into the geometric form when you draw the actual tree.

Trees. The leafy masses of these three trees are all roughly circular, although the actual outline of the trees contains big gaps and doesn't look circular at first glance. The trunks are basically cylindrical, even though each trunk diverges to form branches above and spreads slightly at the bottom of the cylinder where the roots go underground. These spherical and cylindrical forms will become more apparent when you add light and shade to the trees.

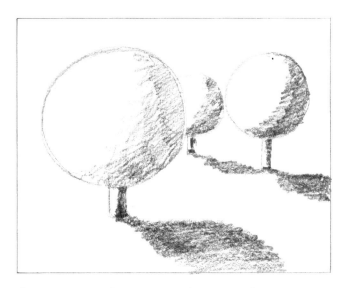

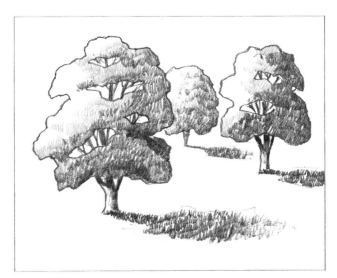

Spheres (Plus Cylinders) in Light and Shade. Before you start to add tone to the trees, remember what you've learned about the gradation of light, halftone (or middletone), shadow, and reflected light on spheres and cylinders. Remember, too, that a rounded form casts a rounded—or elliptical—shadow on the ground.

Trees in Light and Shade. The tones of the leafy masses follow the same progression as the tones on the geometric sphere. Although your pencil strokes can look rough and irregular—to convey the texture and detail of the leaves—place your lighter strokes in the halftone areas, your darker strokes in the shadows, and allow some space between the strokes to suggest reflected light within the shadows. Follow the same sequence of tones when you render the cylindrical trunks and branches. Group your "grassy" strokes to make the shadows look like rough ellipses.

Step 1. Drawing outdoors, you often find trees and rocks with shapes that are essentially round. In this landscape drawing, the artist begins by drawing circular guidelines with light touches of a sharpened pencil. Then, working within the simple geometric shapes, he constructs the realistic shapes of the trees and rocks. Notice how the irregular outlines of the trees move back and forth over the circular shapes but still remain roughly faithful to the circle. The rocks really start out as half circles, since the lower part of the rock is buried in the ground, and then the artist draws flatter, more angular lines over the half circles.

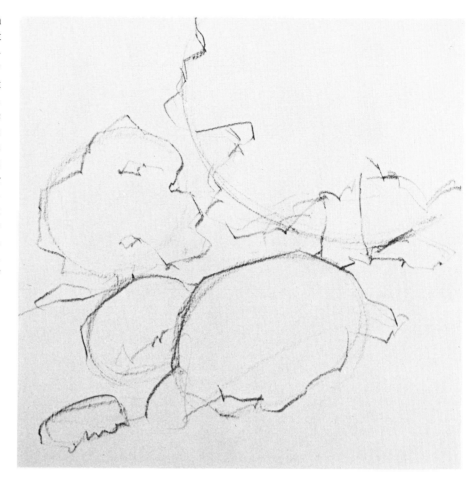

Step 2. Using the side of the pencil, the artist blocks in the big shapes of the darks. The sunlight comes from the sky in the upper left, so the darks appear on the right sides and on the undersides of the leafy masses—and on the right sides of the boulders. The cylindrical tree trunks are mostly in shadow. As he blocks in the tones, the artist keeps in mind the behavior of light and shade on spherical forms.

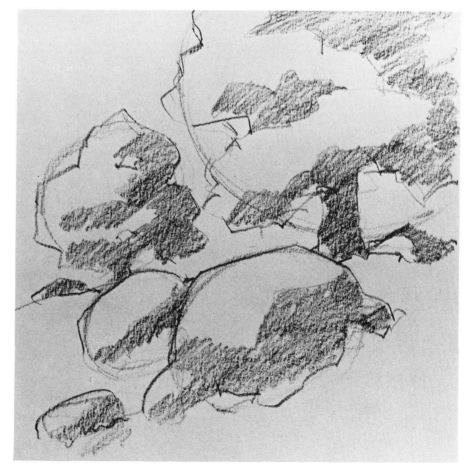

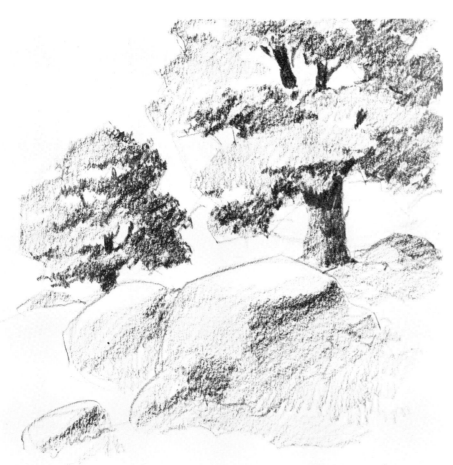

Step 3. Now the artist adds the halftones (or middletones) and strengthens the darks. Although the tones are obviously broken up by the clusters of foliage, it's easy to see how the tones on the smaller tree at the left behave like the gradations on a sphere. The tones on the big tree trunk at the right are like the gradations on a cylinder. The artist establishes a strong distinction between the lighted tops and shadowy sides of the rocks, which now look blockier—like spheres that have been flattened. Notice how the shadow sides of the rocks grow lighter toward the right, where they pick up some reflected light from the sky.

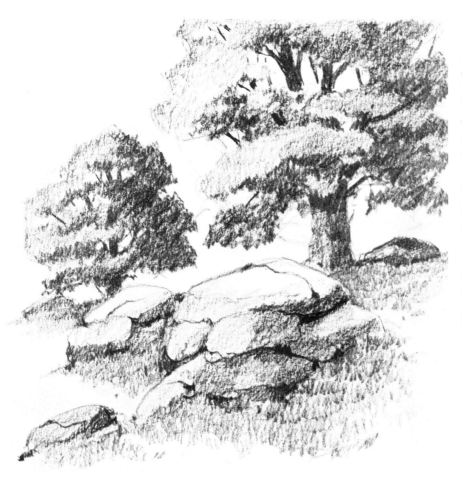

Step 4. So far, the artist has been working entirely with big masses of tone. Now he goes back to add the details and strengthen the tones in the final stage of drawing. He adds more branches to the trees, broadens and darkens the shadows on the leaves, and suggests individual leaves with quick strokes made by using the side of the pencil. He scribbles in the grass with short vertical strokes. And most interesting of all, he takes the big geometric shapes of the rocks and breaks them into smaller shapes by adding cracks and stronger shadows. Half-close your eyes and you'll see that the clusters of rocks here are really quite faithful to the simplified geometric shapes of the rocks in Steps 2 and 3.

Construction Lines. Obviously, there are landscape subjects that you *can't* start out by drawing as cubes, cylinders, or spheres. Although you can't find a geometric shape that does the job, you *can* study your subject carefully and draw simple shapes that will act as guidelines. Here's how you might visualize some clumps of snow on the branches of a tree.

Snow-Covered Branch. Having drawn the simplified shape with free, rapid strokes, you can go back over those guidelines with more precise strokes that render the snow, foliage, and branches more realistically. When you erase the original guidelines, you have an accurate line drawing of your subject—handsome even without light and shade.

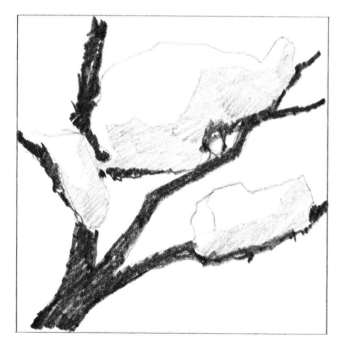

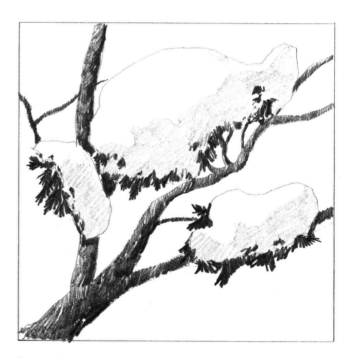

Light and Shade. On this irregular form, light and shade won't behave as they do on geometric forms, but study each shadow carefully and you'll find that it does have its own distinct shape. Begin by sketching the simple shadow shape and filling it with tone—or just keep the simplified shape of the shadow in mind when you make a realistic drawing like the one at right.

Snow-Covered Branch in Light and Shade. The realistic line drawing at the top of the page becomes three-dimensional as the artist adds tones to the masses of snow, as well as to the branches and foliage. The clumps of snow aren't soft, shapeless masses, but have distinct planes of light and shadow which give them a feeling of realism and solidity.

Construction Lines. Some nongeometric shapes seem hard to draw because they keep moving and changing— such as a crashing wave. Keep your eye on the exact spot where wave after wave hits the same rock formation, and you'll find that the leaping surf assumes a similar shape again and again. Fix that shape firmly in your mind and record the contours with a few rapid strokes.

Surf. Don't worry if your first rapid, highly simplified drawing doesn't look much like surf and rocks. Now you can go back to work, observing the surf and rocks more carefully and converting the simplified shapes to a more realistic line drawing. The important thing to remember is that the shape of the surf isn't vague and fluffy, but just as solid as the rocks.

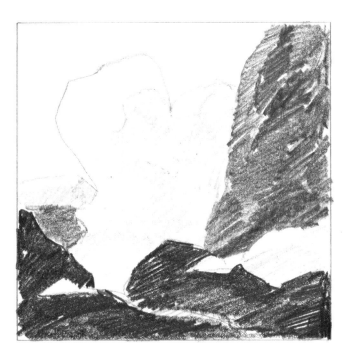

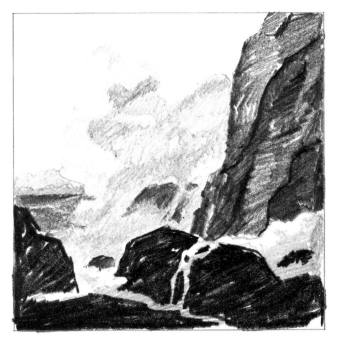

Light and Shade. Now study the distribution of light and shade on the surf as it continues to break against the rocks. Like any other solid form, the surf has distinct planes of light and shadow. You can make a highly simplified sketch of the light and shadow shapes—as you see here—or just keep these shapes in mind when you do a more realistic drawing like the one at right.

Surf in Light and Shade. Here's a more realistic drawing of the light and shade on the surf and rocks. The tonal areas are rendered with broad strokes, made with the side of the pencil. The original line drawing is erased. Now the planes of light and shadow stand by themselves, equally distinct on the pale form of the surf and the darker forms of the rocks.

Step 1. Because clouds often have fuzzy edges and change constantly as they're pushed along by the wind, they may seem vague and shapeless at first glance. But every cloud has a distinct shape, even though it may not be a geometric one. Here, the artist concentrates on the broad outlines of a few cloud shapes—paying no attention to the intricate contours—and quickly records these outlines with a minimum number of strokes. At this stage, the clouds don't look soft and puffy, but that doesn't matter. What's essential is to put some guidelines on paper as rapidly as possible. The clouds can be made rounder and softer in the next stage.

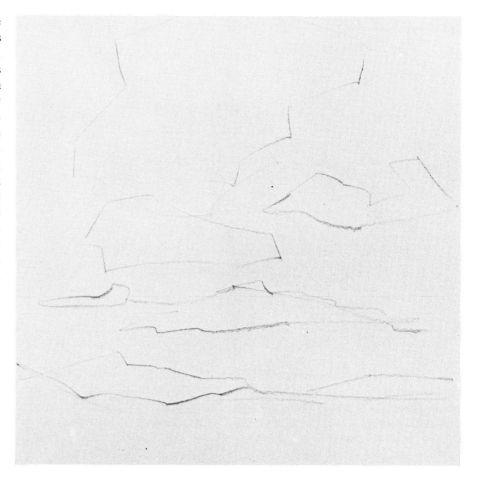

Step 2. By the time the guidelines of Step 1 are on the paper, the clouds have already begun to change form as they move across the sky. Still working quickly, the artist studies the moving shapes in the sky and draws freely around the guidelines with rounder, more precise strokes that produce a more realistic rendering of the clouds. He doesn't follow the guidelines slavishly, but arrives at a kind of compromise between the highly simplified shapes of Step 1 and the rounder, softer, more intricate shapes of the clouds. Step 1 also contains guidelines for the hills, which he reinforces here.

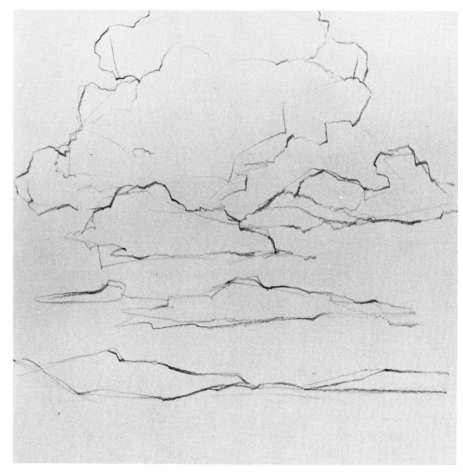

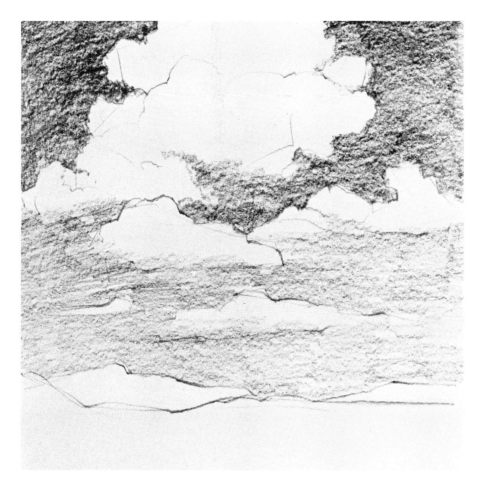

Step 3. Working with the side of the pencil, the artist moves around the cloud shapes with broad, rough strokes that are broken up by the texture of the paper. He fills the cloudless areas of the sky with tones that surround the cloud shapes and make them more distinct. Notice how the sky grows darker at the zenith and paler at the horizon.

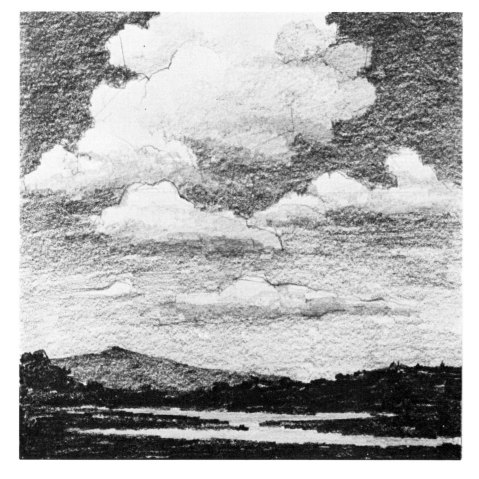

Step 4. Finally, the artist blocks in the shadow areas of the clouds with broad strokes that are paler than the surrounding sky. He doesn't scrub in patches of tone indiscriminately, but remembers that a cloud is a solid, three-dimensional form with clearly defined areas of light and shadow. In this drawing, the light strikes the clouds from above and to the left, which means that the shadow areas will be on the right sides and along the bottoms of the forms. The completed clouds look soft, but as round and solid as any geometric form. The artist finishes the drawing by darkening the shapes of the landscape with broad horizontal strokes, using the side of the pencil.

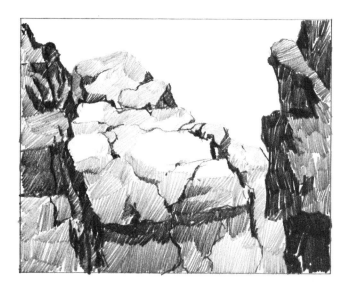

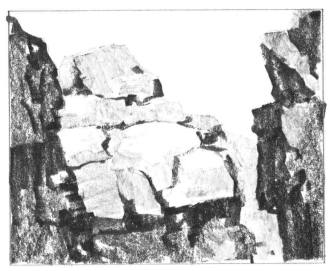

Slender Strokes. There are many ways to render landscape forms with a graphite pencil. Working with the sharpened tip of the pencil, you can build up the halftones and shadows with groups of parallel strokes, as you see here. Notice the direction of the strokes: some move across the tops of the rocks, while others slant down the diagonal planes and move down over the vertical planes. The artist presses lightly on the pencil for the halftones, leaving spaces between the strokes. For the darker tones, he presses harder on the pencil and leaves less space between the strokes.

Broad Strokes. The pencil can be used in a totally different way to draw the same subject. You can use the side of the lead or you can sandpaper the tip to a broad, flat shape for making wider strokes—like the strokes made by the squarish end of an oil-painting brush. In this study of the same rock formation, the artist creates blocks of tone by laying broad strokes side by side. He puts less pressure on the pencil for the paler tones and presses harder for the dark tones. He places the pale strokes side by side, but piles one stroke over another for the darker areas.

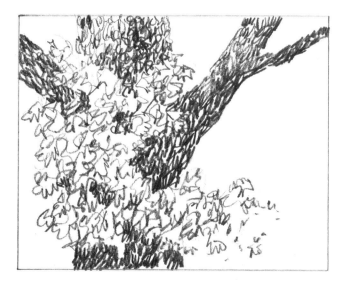

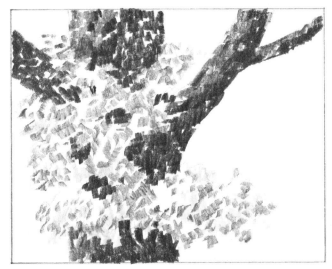

Scribbled Strokes. The movement and direction of your pencil strokes will also make an important difference in the character of the drawing. To render the rough bark of a tree and the lively detail of the foliage, you might choose short, scribbled strokes like those in this drawing. The artist moves his pencil quickly back and forth, placing his strokes close together to suggest the dark tone and rough texture of the branches. He uses a more open scribble—with more space between and around the strokes—to suggest the paler tone and the lacy texture of the leaves.

Straight Strokes. Now, blunting his pencil point on a sandpaper block, the artist renders the tone and texture of the same branches with short, thick strokes. He packs his strokes densely, side by side, applying less pressure in the lighted areas and pressing harder on the shadow sides of the branches. He lets the strokes show distinctly to suggest the roughness of the bark. He uses the same kind of strokes to suggest the cluster of leaves, but then he allows more space between the strokes, allowing the bare paper to show through to suggest the flicker of sunlight on the foliage.

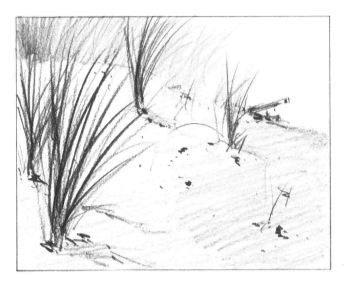

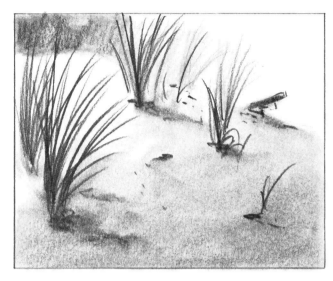

Modeling with Strokes. In this close-up of a section of a large landscape, you can see how the artist uses long, parallel strokes to model the form and suggest the gradation of light and shade on a sand dune. The parallel strokes move diagonally over the shape of the dune to suggest the slant of the beach. At the same time, the strokes gradually grow darker as they move toward the lower right, suggesting the gradation from sunlight to halftone to shadow. The clumps of beach grass are drawn with sharp, curving strokes, paler in the distance and darker in the foreground.

Modeling by Blending. Here's an alternate way to model the solid form of the dune. Beginning with strokes similar to those in the illustration at left, the artist blends the strokes with a fingertip—or with a stomp—so that the strokes disappear and merge into a soft, velvety tone. Once again, the tone is darkest at the right and at the lower edge of the picture to suggest the gradation from light to halftone to shadow. The beach grass in the foreground is drawn with distinct strokes, while the distant clump of grass in the upper left is blended and looks more remote.

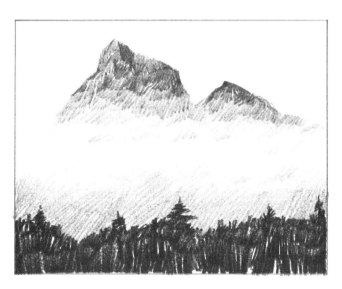

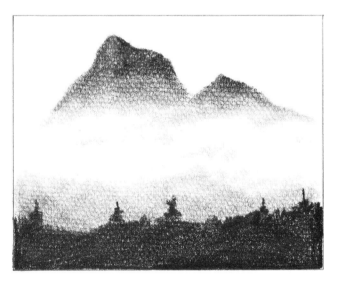

Strokes on Rough Paper. Rough paper tends to blur and soften the pencil stroke, so this surface is particularly effective when you want to create a sense of atmosphere and distance in a subject like these misty mountains. The artist works with clusters of strokes. He lets the pencil point glide lightly over the textured paper to produce the evanescent tones where the mountains fade into the mist. He really bears down strongly on the point to draw the dark trees, and then he moves softly over the paper to suggest the misty tones above them.

Blending on Rough Paper. Textured paper also lends itself to the soft, blended tones made by a fingertip or a stomp. Here, the artist redraws the misty mountains with strokes similar to those in the drawing at left, but this time he blends them until the strokes disappear and form a soft veil of tone. You'll find it particularly easy to create beautiful blended tones on rough paper. And, as you see here, the texture of the paper shows through the blended tones, making them look more vibrant.

Step 1. Certainly one of the most common landscape elements—and one of the most beautiful to draw—is the bold form of a tree in full leaf. Such a tree is full of intricate texture and rich detail, which you must force yourself to ignore in the first stages of your drawing. Observe how the artist draws the masses of leaves as big, jagged shapes, paying no attention to individual leaves but concentrating entirely on a highly simplified outline. He also looks for gaps where the sky shines through the leaves. And he makes a quick, relaxed contour drawing of the trunk and branches, concentrating on the major shapes and omitting the smaller branches that will appear later. Just a few lines suggest the ground, rocks, and distant hill.

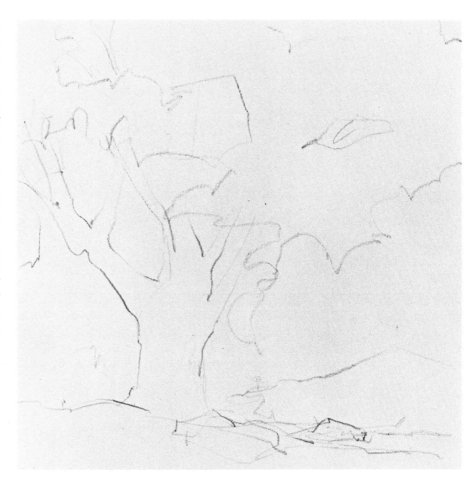

Step 2. Pressing harder on the point of his pencil, the artist goes back over the leafy shapes with short, curving, expressive lines that begin to suggest foliage—but he still doesn't draw a single leaf. He also studies the trunk and branches more closely, drawing the shapes more precisely and indicating some more branches. Finally, he strengthens the contours of the foreground rocks, the shrubs, and the hill in the lower right. The drawing is accurate, but still very simple.

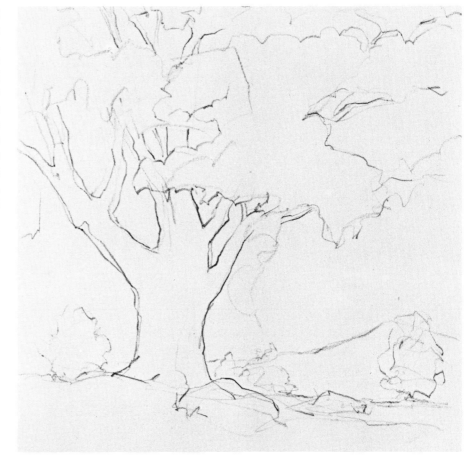

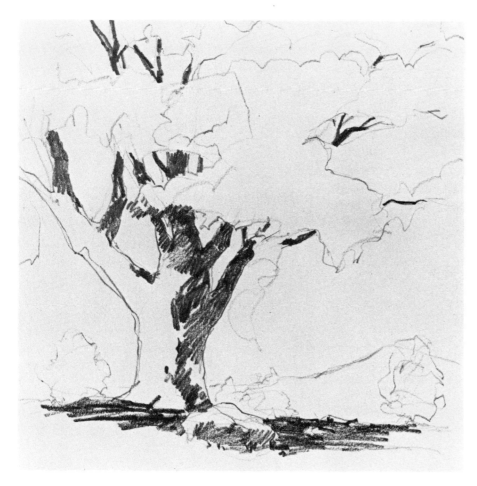

Step 3. The next step is to block in the shapes of the darks. The line drawing has been done with an HB pencil, but now the artist reaches for a softer, darker 3B pencil, which he turns sideways to block in the tones with the side of the lead. He works with broad parallel strokes to create patches of tone. After covering the shadow areas of the main trunk, he moves upward to indicate the shadowy branches showing through the gaps in the foliage. With long, horizontal strokes, he suggests the shadow that the tree casts on the ground. And he blocks in the shadowy side plane of the rock in the foreground.

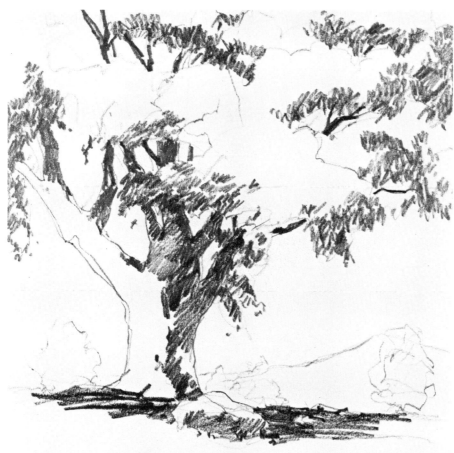

Step 4. Still concentrating on the shadow, the artist switches his attention to the masses of leaves. The shadows appear on the undersides of the leafy masses; the artist draws them with dark, scribbly strokes that actually suggest the texture of the leaves. As he moves the pencil back and forth, he changes direction slightly to suggest the irregular clusters of foliage. Not a single leaf is actually drawn, but the expressive strokes give you the feeling that the leaves are really there.

Step 5. The artist moves on to the lighted areas of the trunk, the big branch at the left, and the foliage above. Notice how he works with clusters of parallel strokes that suggest patches of tone on the trunk and branch, while also conveying the texture of the bark. The pale groups of leaves are also drawn with clusters of pencil strokes, but these clusters are smaller and keep changing direction. Some leafy strokes are slanted, while others are more horizontal or vertical. And some strokes are straight, while other curve slightly. This random pattern of leafy strokes is a very simple means of suggesting rich texture and detail. The artist also adds tone to the lighted top of the foreground rock.

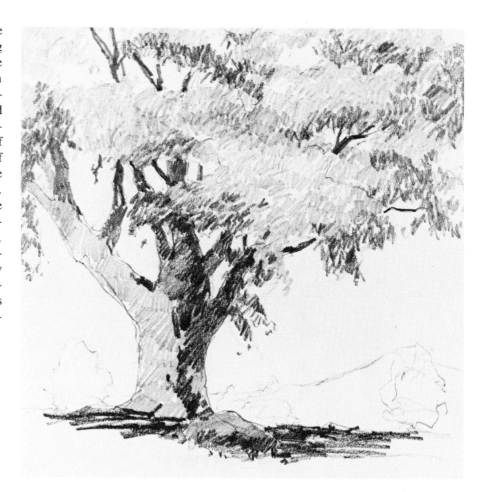

Step 6. Having established the broad distribution of tones on the tree and in the foreground, the artist can now begin to strengthen these tones and suggest more detail. Pressing harder on the side of the 3B pencil, he piles stroke over stroke to darken the shadow sides of the trunk and branches, also suggesting a few cracks in the trunk. (Notice how the trunk is modeled like a cylinder, with a hint of reflected light at the right.) The artist also builds up the dark undersides of the leafy masses with darker, denser, scribbly strokes. He adds more dark branches in the gaps between clusters of leaves. He covers the distant hills and trees with broad, pale strokes that make them seem remote. And a few touches of the pencil suggest grass.

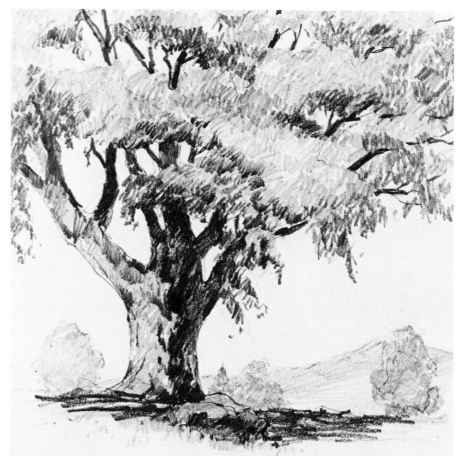

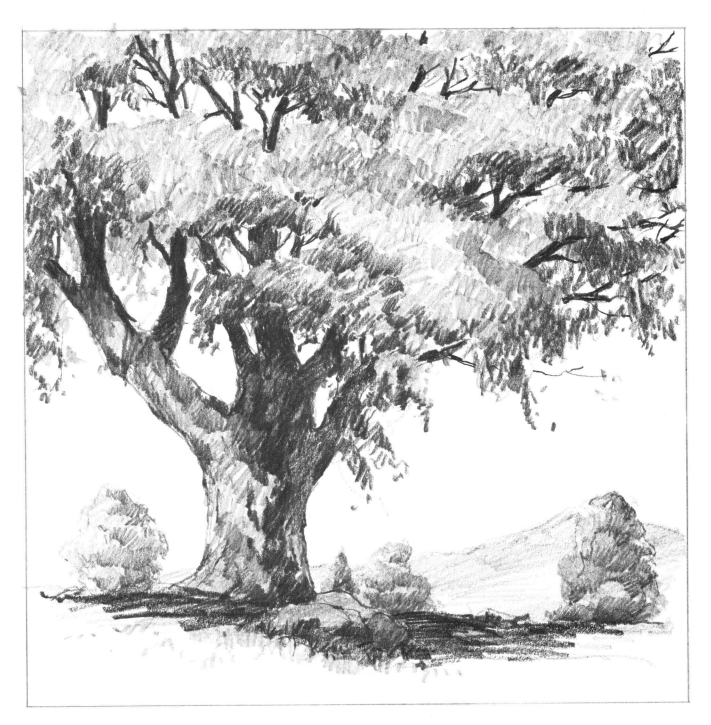

Step 7. In the final stage of the drawing, the artist continues to deepen the tones and add detail and texture. Smaller clusters of strokes enrich the texture of the thick trunk and lower branches. The shadowy undersides of the leafy masses are darkened with short, scribbly strokes—most apparent on the right. The sharp point of a 2B pencil adds slender twigs among the foliage; you can see these most clearly on the right and toward the top of the picture. Here and there, a quick touch of the pencil suggests a single leaf hanging down from the mass of foliage and silhouetted against the sky. The side of the HB pencil darkens the shadow on the ground with horizontal strokes. Pressing more lightly on the pencil, the artist adds shadows to the distant trees and darkens the slope of the distant hill—but these remain distinctly lighter than the big tree. The landscape obeys the rules of aerial perspective: foreground objects are darker and more detailed, while the shapes in the distance are paler and show a minimum of detail. This demonstration is also a good example of a drawing in which a wealth of texture and detail is rendered very simply: the artist relies primarily on clusters of broad strokes, made by the side of the pencil.

Step 1. It's important to explore all the different kinds of strokes that you can make with a graphite pencil. A subject such as a meadow—with rocks, trees, and hills in the distance—will challenge you to find varied combinations of lines and strokes to suit the various parts of the landscape. As always, it's best to start with a very simple line drawing of the main shapes, as the artist does here. It's really impossible to suggest the intricate detail of the meadow at this stage, so the artist draws just the distant rock formation and suggests the trees and one hill beyond. He works with the sharp point of a 2B pencil, gliding lightly over the surface of the drawing paper.

Step 2. Now he sharpens the contours of the rock formation and draws the shapes more precisely, looking for the divisions among the rocks. He also draws the spiky shapes of the trees more distinctly but doesn't define them too precisely, since the preliminary line drawing will soon be covered with broad strokes. A few slanted lines place the hills in the distance. And a very important scribble establishes the division between the shadowy foreground of the meadow and the sunlit field beyond—a division which won't become apparent until the final stage of the drawing.

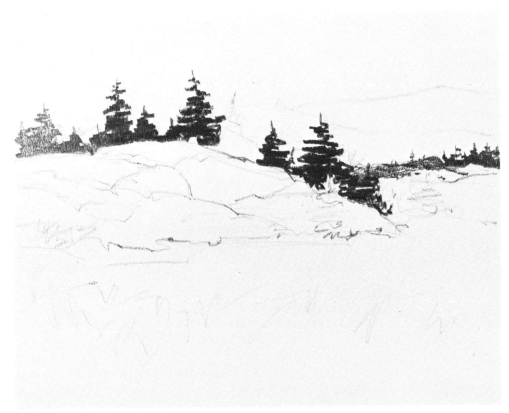

Step 3. With a thick, dark 4B pencil sandpapered to a flattened tip, the artist begins by drawing the darkest notes in the landscape: the evergreens above the rock formation. He draws the clusters of foliage with broad, horizontal lines, allowing gaps of sky to show through. He applies more pressure on the pencil to suggest that some trees are nearer and darker than others. The trees at the extreme left—and the strip of very distant trees at the extreme right—are drawn with lighter strokes to suggest the effect of aerial perspective. The trunk of each tree is a single slender, vertical stroke.

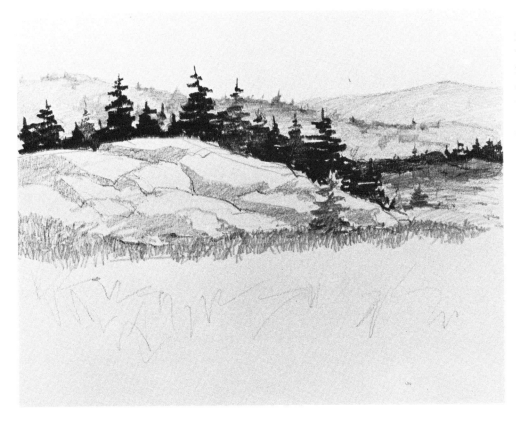

Step 4. With the side of the 2B pencil, the artist blocks in the shadow planes of the rock formation. The sunlit tops and the shadowy sides are clearly defined. He begins to suggest the grass at the base of the rock formation with short, scribbly vertical strokes. He adds paler trees above and below the rocks, again working with horizontal strokes for the masses of foliage. Letting the side of the pencil glide lightly over the paper, he covers the distant hills with tone and suggests a few trees on the long slope behind the darker trees. Notice how the nearest hill at right—the low one crowned with a slender grove of trees—is darker than the hills beyond.

Step 5. The artist covers the entire meadow with clusters of slender strokes, using the tip of the 2B pencil. He applies very little pressure, moving the pencil rapidly up and down, and changing direction slightly so that some clusters lean to the left and others, to the right. The scribbly marks of the pencil are short and dense in the distance, gradually growing longer as they approach foreground. You already have a distinct sense of distance, since the foreground grasses are taller and more distinct than those in the distance. The artist darkens the low hill at the right with vertical strokes.

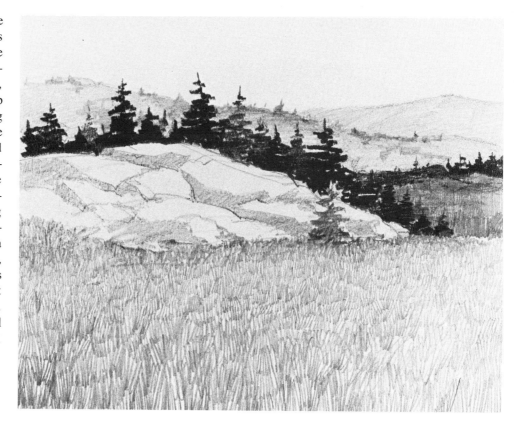

Step 6. Moving away from the foreground for a moment, the artist concentrates on the rocks and trees in the middleground. Pressing hard on the point of a 3B pencil, he draws the cracks between the rocks with strong, dark strokes and begins to darken the shadows within these cracks. He breaks up the original forms to suggest more rocks than were there before. He draws the trunks and branches of some leafless trees at the left along the top of the rock formation, also adding more evergreens at the extreme right. The rock formation casts a shadow on the meadow at the extreme left, which the artist suggests by adding short, dark strokes to the grass.

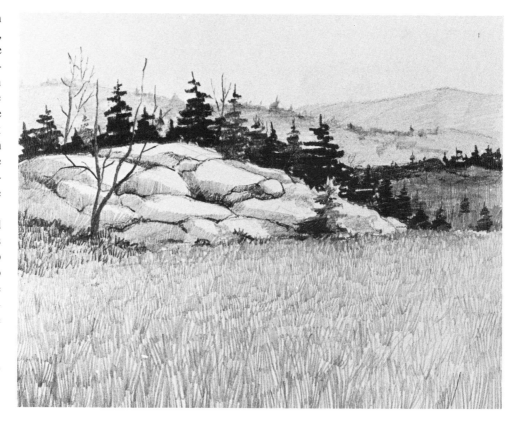

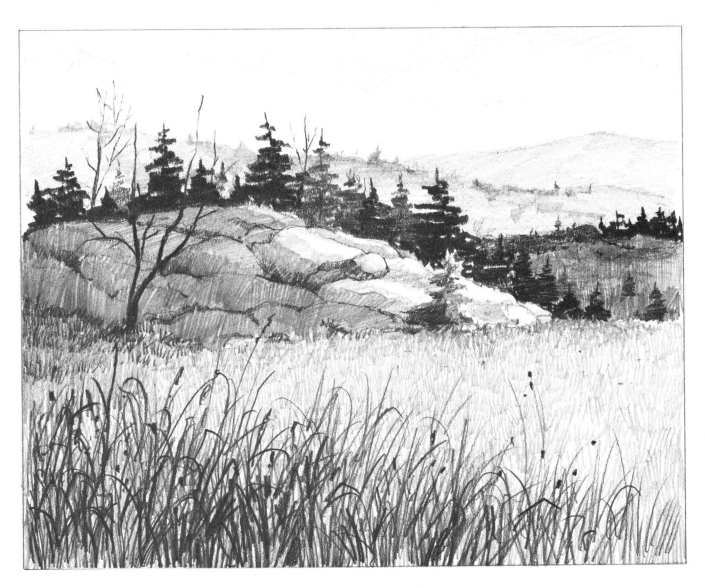

Step 7. Actually, most of the rock formation is in shadow, but the artist waited to add this big patch of shadow until he'd defined the shapes of the rock in Steps 1 through 6. Now he goes back over the rock formation with broad parallel strokes to cover almost all of the rocks with shadow, leaving only a few patches of sunlight. Suddenly there's a much more dramatic contrast between the shadowy rocks and the sunlit meadow. To make the one bare tree stand out against the shadowy sides of the rocks, he darkens the trunk and branches. But now the artist remembers the scribbly line that appeared across the foreground in Step 2—and which has long since disappeared. That scribbly line established the division between the dark weeds and grasses in the immediate foreground and the sunny area of the meadow beyond. With the sharpened point of the 2B pencil, the artist adds the rich detail of the weeds and grasses at the lower edge of the picture, working with a lively pattern of slanted and curving strokes, some dark and some light, always leaving gaps between the strokes to let the sunlight shine through. The intricate detail of the meadow is kept entirely in the foreground; the sunlit area is left alone. Too much detail would confuse and distract the viewer—and the artist knows just when to stop. A few groups of slanting strokes suggest clouds in the sky, and the drawing is done. Now, before going on to the next demonstration, see how many different kinds of strokes you can find in this study of the meadow. Compare the broad, rough, horizontal strokes of the trees; the patches of straight, slender strokes representing the shadow side of the rock formation; the slender, scribbly strokes of the meadow; the long, crisp, rhythmic strokes of the grasses and weeds in the foreground; and the soft slanted strokes that represent the distant hills and sky.

Step 1. To learn how pencil behaves on rough paper, find a landscape subject that contains a variety of textures—like this demonstration combining the smooth texture of water, the rough texture of a rocky shore, and the surrounding detail of trees. This subject is rich in detail, but the artist begins with a very simple line drawing of the main shapes. He draws the edges of the shore and the shapes of the shoreline; the trunks of the trees on either side of the stream; and the masses of foliage—all with a minimum number of lines. The artist visualizes everything as simple shapes in which the subject is barely recognizable.

Step 2. Working with the same sharply pointed HB pencil he used in Step 1, the artist carefully converts those first few lines into a realistic line drawing of the complete landscape. The shoreline rocks, fallen tree trunk, upright trunks, and distant, tree-lined shore emerge clearly. The pencil lines are still relaxed and casual. They're not too precise because the artist knows that they'll soon disappear under strokes and masses of tone. Notice how this line drawing already begins to obey the rules of aerial perspective: the rocks, trees, and fallen tree trunk in the foreground are drawn with more precision and detail than the simple masses of the distant shoreline.

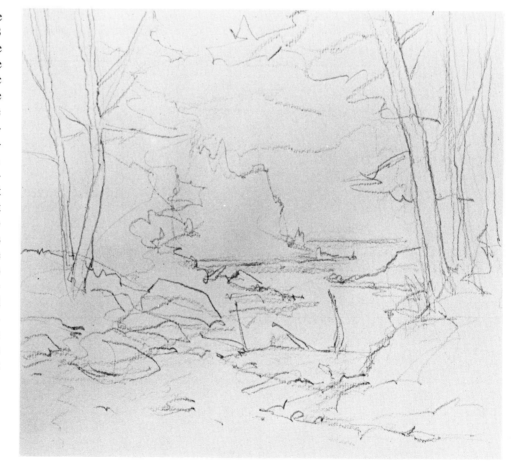

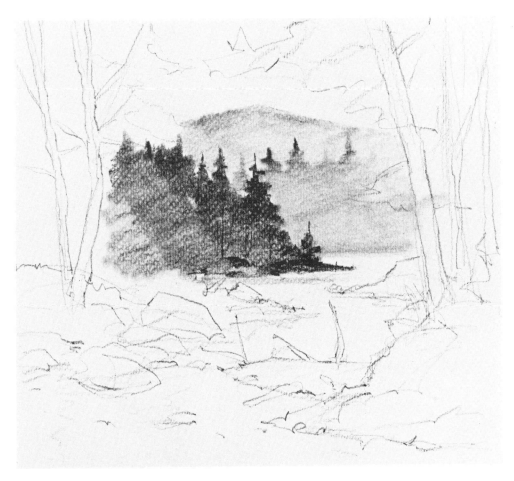

Step 3. Because he wants his drawing to have a sense of deep space, the artist starts with the most distant forms. He moves the side of a 4B pencil lightly over the textured paper and blends the strokes with his finger to create veils of tone for the distant hill and the tree-covered shoreline. For the nearer, darker shoreline, he presses harder on the pencil and blends the tones lightly, allowing some strokes to show. He presses just a bit harder on the pencil to suggest the shapes of some evergreens—drawing the foliage with horizontal strokes and the trunks with vertical ones. The shapes of the distant landscape are in correct aerial perspective.

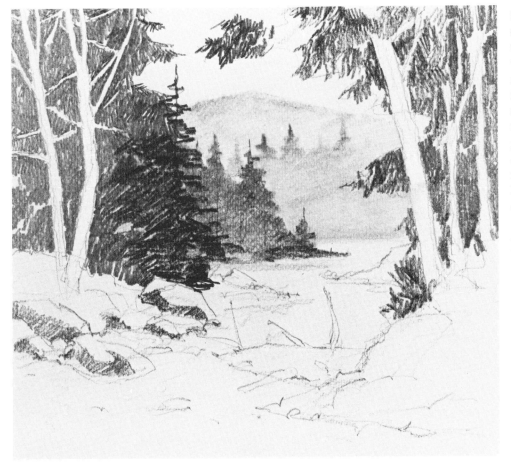

Step 4. Moving to the middleground, the artist switches to a slightly harder 2B pencil which will draw more precise strokes. Working around the tree trunks on each side of the stream, the artist draws clusters of parallel strokes to suggest the foliage behind and around the trees. To draw the foliage at the right, he presses harder on the pencil and draws more distinct strokes to suggest that the foliage is closer to the foreground. With parallel slanted strokes, the artist blocks in the shadowy sides of the rocks at the left. Pressing really hard on the pencil, the artist adds a new element to the picture: he creates a dark evergreen to the left of the stream.

Step 5. The artist blocks in the shadow planes of the rock formation at the lower right and adds grass to both shores with clusters of short vertical strokes—packing these strokes densely together to suggest the shadow beneath the tree at the left. Moving upward, he models the pale tree trunks at the left like crooked cylinders: you can see the gradation from light to dark. The trees at the right have a rough, patchy tone, which the artist renders with clusters of dark and light strokes. Piling a dense layer of new strokes on the dark evergreen at the left, the artist deepens the tone of the foliage. Between the two groups of trees, he adds some smaller rocks that jut out into the stream.

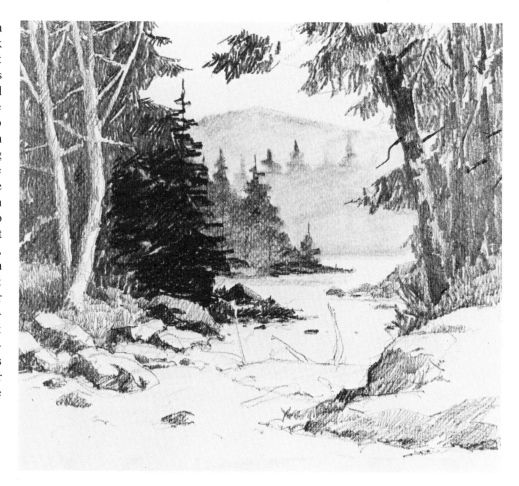

Step 6. The artist moves to the foreground. He draws the fallen tree trunk in the stream with a sharply pointed 2B pencil, emphasizing the crisp detail of the trunk and branches —and modeling the tones—with clusters of slender, distinct lines. With the side of a thick, soft 4B pencil, he darkens the shadow planes on the rock formation at the lower right and then adds broad, wiggly strokes to the water, suggesting the movement of the stream and the lively reflection of the trees at the left. He blends these tones with a stomp, making more wiggly lines with the darkened tip of the stomp. Then he adds even darker reflections over the blended tones at the lower left.

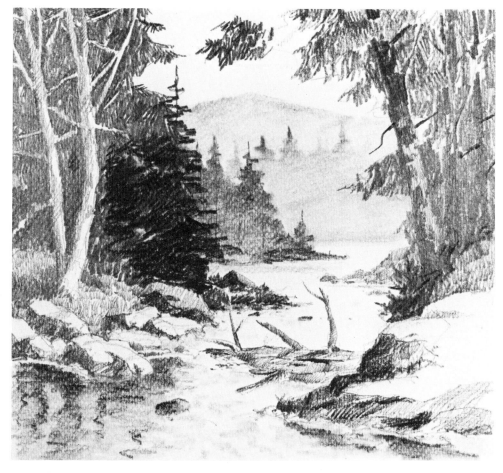

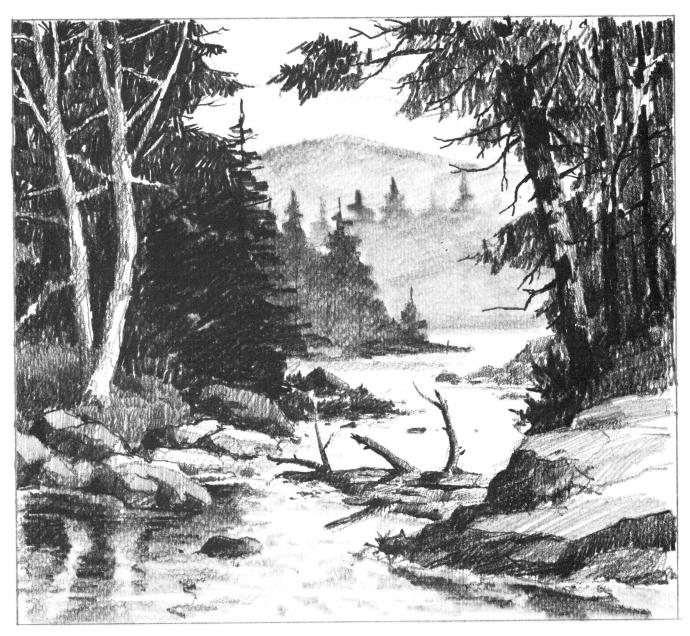

Step 7. Now the artist moves back over the entire picture with a sharply pointed 3B pencil to add crisp touches of detail, and with a blunt-tipped 4B pencil to darken the tones. Fresh clusters of parallel strokes darken the foliage. The pointed pencil adds more branches and twigs. Now the pale tree trunks at the left stand out more brightly against the dark background of the foliage. To make the darker trunks at the right stand out too, the thick pencil darkens the trunks with vertical black strokes. The sharp pencil moves downward to darken the grass with dense clusters of vertical strokes—which are also carried over the rocks at the left, leaving occasional patches of bare paper to suggest flashes of sunlight. Clusters of slanted strokes darken the tops of the rocks on the lower right, again leaving an occasional patch of bare paper to suggest sunlight. The sharp pencil strengthens the jagged contours of the fallen tree trunk in the stream, darkens the cracks in the trunk, and deepens the shadows. The sharp pencil also adds wiggly strokes on the lower left to darken the reflections. The stomp blends some of these strokes but leaves others intact—and then the graphite-coated point of the stomp adds soft, wiggly strokes to the sunlit center of the stream. Finally, the artist goes back over the pale hill silhouetted against the sky and the tree-covered shoreline in the distance, to darken these shapes very slightly; the stomp blends the pencil strokes into soft, misty tones. To emphasize the contrast between the darks of the shoreline and the sunlit areas of the water and sky, the artist squeezes a kneaded rubber eraser to a narrow wedge shape and carefully cleans the areas of bare paper. The sharp point of a pink rubber eraser is drawn across the foreground stream to suggest bright lines of sunlight reflected in the water. Finally, the tip of the kneaded rubber eraser is squeezed to a point to brighten the sunlit patches on the tree trunks and rocks at the left. Notice how the rough texture of the paper performs two very different functions. The tooth of the paper enlivens the rich pattern of strokes that render the foliage, grass, and rocks. And the pebbly texture of the paper lends a soft, airy quality to the smudged sections—in the water and in the distant hills.

Step 1. One of the great advantages of textured paper—whether it's charcoal paper or something even rougher—is that you can do a lot of blending without making the drawing look vague and blurry. The texture of the paper makes the blended tones look bold and vital. A coastal landscape, with its smooth sand and rugged rocks, will give you a good chance to combine soft blending with bold strokes. In this preliminary line drawing, the artist concentrates entirely on the silhouettes of the big rock formations and the zigzag lines of the shore. The lines are drawn lightly with an HB pencil; they'll disappear under firmer lines in Step 2.

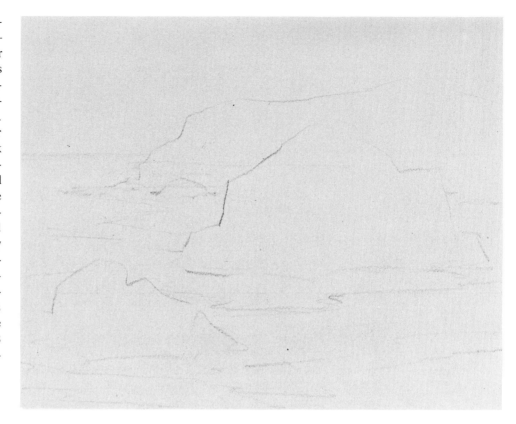

Step 2. Studying the shapes of the rocks and shoreline more closely, the artist draws the exact contours with darker lines. The artist is free to redesign nature when necessary, so he decides that the big central rock is too low—and he dramatizes the form by pushing it higher into the sky. Inside its dark contours, as well as those of the smaller rock on the lower left, he draws lighter lines to suggest the division between light and shadow. This division will become more apparent in Step 3. Notice how carefully he draws the shape of the tidal pool that wanders across the beach in the foreground.

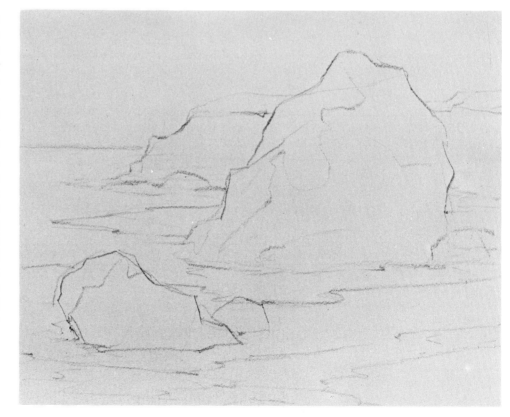

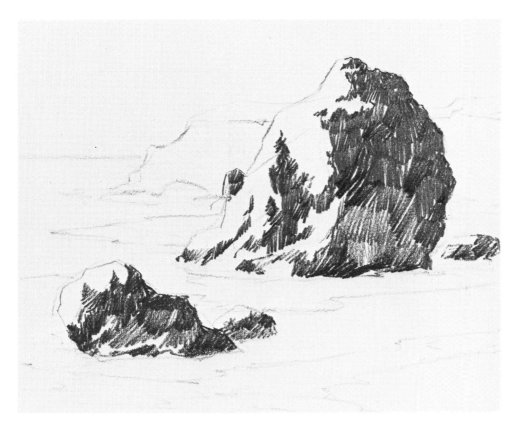

Step 3. The artist squares up the tip of a 2B pencil by rubbing it against a sandpaper pad. Then he renders the shadowy sides of the foreground rocks with clusters of parallel strokes. Notice how the groups of strokes change direction slightly to suggest the ragged, irregular shape of the rock. Compare the rendering of the shadows here with the delicate line that divides light from shadow in Step 2. That line in Step 2 may look casual, but it becomes a very useful guide when the artist begins to render the tones in this step. Observe how the rough paper breaks up the pencil strokes and emphasizes the rugged texture of the rocks.

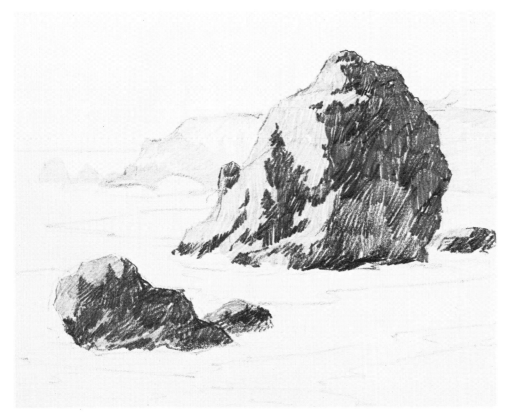

Step 4. Pressing lightly on the squarish end of the same pencil, the artist covers the lighted planes of the rocks with clusters of parallel pale strokes. As he's done in the shadows, he changes the direction of the clusters to suggest the irregular shapes of the rocks. Moving into the distance, he adds a still paler tone to the rocky headland and to the small rocks in the sea at the tip of the headland. To render this pale tone, the pencil glides lightly over the surface of the paper; the strokes are almost invisible.

Step 5. It's easy to blend the broad strokes of a soft pencil. So now the artist picks up a 4B pencil with a blunted tip and lets it skate very lightly over the pebbly surface of the paper to darken the tones of the beach—leaving bare white paper for the tidal pool. He blends these pale strokes with a stomp, merging them into delicate gray shapes. He also goes over the shape of the distant headland with the stomp, making the tones softer and more remote. The drawing begins to display a dramatic contrast between the rough strokes of the rocks and the soft, blended tones of the sand.

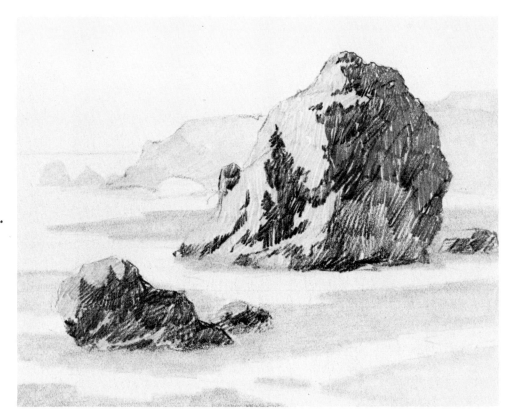

Step 6 (Close-up). Here's a close-up of a section of the finished drawing. In this final step, the artist accentuates the dramatic contrast between the blended tones of the beach and the boldly textured tones of the rocks. With a thick, soft, blunt-ended 4B pencil, the artist blackens the shadow planes of the rocks with clusters of scribbly diagonal strokes. Then he darkens the lighter planes as well, using the side of a 2B pencil. He darkens and blends the sand, and then adds a reflection in the tidal pool with the 4B pencil, blending the edges of the reflection with the stomp.

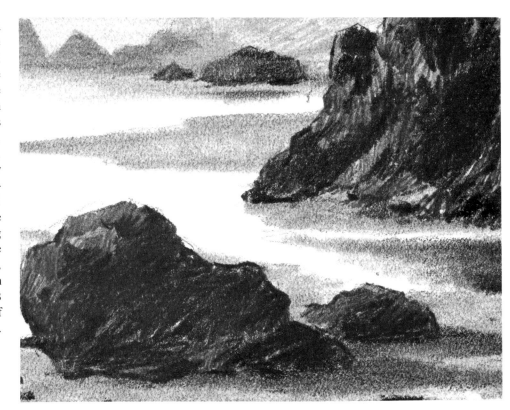

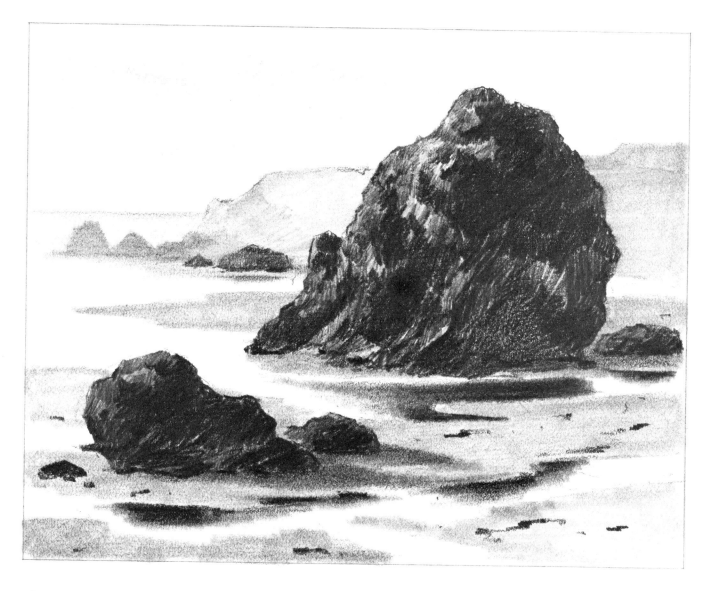

Step 6. This overall view of Step 6 shows how the artist has blackened the big rock with broad strokes of the 4B pencil. Notice how the pencil strokes are drawn in clusters, allowing hints of white paper to show through in order to suggest areas of the rock that receive more light. The tooth of the paper breaks up the strokes and adds to the illusion of texture in the rocks. The strips of sand have all been darkened slightly and blended with the stomp. Shadows are added to the right of the foreground rocks—with pencil strokes carefully blended by the point of the stomp. The tidal pools, which reflect light from the sky, remain bare paper, but the soft pencil has added the dark reflections of the rocks. These reflections are carefully blended with the stomp. The soft pencil travels lightly over the shape of the distant headland to add just a bit more tone; once again, the headland is blended with the stomp to produce a smooth gray tone. A few light pencil strokes suggest the edge of the sea at the left; these strokes are blended with the tip of the stomp. Finally, the blackened end of the stomp is used like a thick pencil to draw some streaky clouds in the sky. When you do a lot of blending with your fingertip or with a stomp, the white areas of the paper tend to become a bit gray as your hand moves over the drawing. So, to brighten the sky and the strips of bare paper representing the sunlit water, the artist uses two different erasers. He squeezes the kneaded rubber to a point that can get into the intricate shapes of the tidal pools and the foreground. To clean the broader areas of the sea and sky, he uses a wedge-shaped pink rubber eraser. The pink eraser tends to leave tiny crumbs of rubber on the surface of the paper. The artist doesn't brush these away with his hand, which might smudge the drawing, but blows them away. The finished drawing displays a wonderful contrast between the rugged strokes of the pencil, the delicate veils of tone produced by blending, and the brightness of the bare paper.

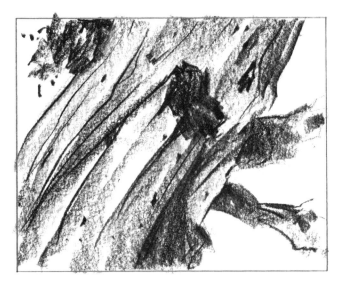

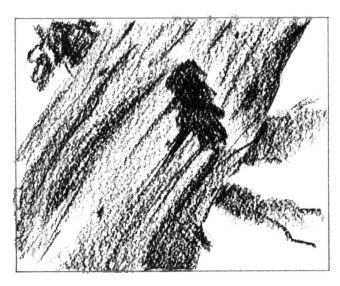

Strokes on Smooth Paper. When you draw with chalk, you'll find that the same subject will look radically different when it's drawn on different kinds of paper. Ordinary drawing paper (cartridge paper in Britain) is relatively smooth but does have a slight texture, which is apparent in this close-up of a tree taken from a larger landscape drawing. Although this texture enlivens the strokes, the marks of the chalk are crisp and distinct on the surface of the sheet. The lines are drawn with a sharp corner of the chalk, while the tones are drawn with the flat end of the chalk.

Strokes on Rough Paper. When the artist switches to rough paper, the pebbly texture of the sheet breaks up the marks made by the chalk. The broad strokes of the flat end of the chalk become wide blurs of tone. You can still see the crisp lines made by the sharp corner of the stick, but these lines are rougher and less distinct. Obviously, you should choose smoother paper for careful, precise drawings, while a rough sheet is best for drawings with bolder strokes and less detail.

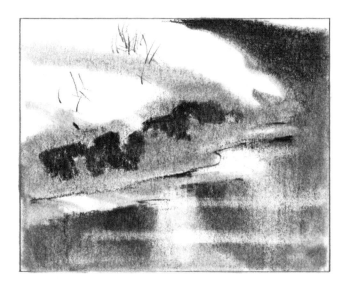

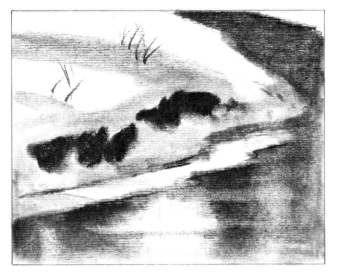

Blending on Smooth Paper. When you apply chalk strokes to smooth paper and smudge them with your fingertip or a stomp, the slight texture of the paper does come through, just as it does when you draw lines and strokes. But the texture of the paper lends a soft, irregular quality to the tones, rather than dominating the drawing. The blended tones have a slightly furry quality, as you can see in this close-up of a snow bank at the edge of a frozen stream.

Blending on Rough Paper. Here's the same subject drawn on the ribbed surface of charcoal paper. Once again, the artist starts with strokes of chalk and then blends them with a stomp. The tooth of the charcoal paper is more insistent than that of ordinary drawing paper, so the texture of the sheet appears in all the tones, making the tones softer and the shapes slightly less distinct. Charcoal paper, by the way, has a very hard surface that will take a lot of blending—and a lot of erasing when necessary.

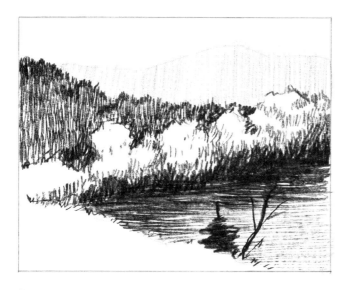

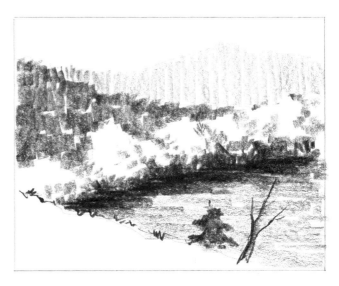

Slender Strokes. The sharp corner of the chalk can build tones with quite slender lines. And chalk in pencil form will make lines as slender as a graphite pencil. In this small section of a larger landscape, all the tones are created with clusters of slim lines. The sharp corner of the chalk glides lightly over the paper to create the palest tones, then presses harder to create the darker ones. The chalk marks are packed tightly together to create the strongest darks.

Broad Strokes. The flat end of the chalk will make broad, squarish strokes. Here's the same subject with the tones rendered in clusters of broad strokes. For his palest tones, the artist presses lightly on the chalk and leaves gaps between the strokes. He presses harder on the chalk and packs the strokes tightly together to create darker tones. The direction of the strokes is also important: notice that the slopes of the mountains are drawn with vertical strokes, while the flat water is drawn with horizontal ones.

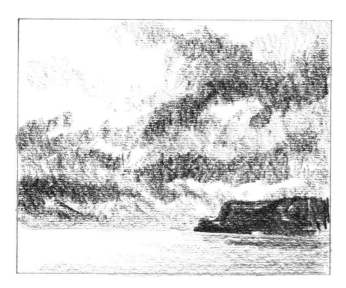

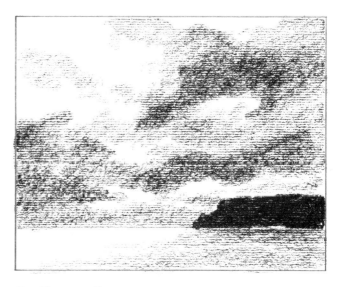

Separate Strokes. When you start a drawing, it's important to decide just what kind of strokes you expect to make. You can keep all your strokes separate and distinct, as you see in this group of clouds from a larger coastal landscape. Although the artist groups and overlaps his strokes, you can see the marks of the chalk quite distinctly. The lively pattern of independent strokes gives a feeling of movement and turbulence to the sky. And the ribbed texture of the charcoal paper roughens the chalk marks, making the clouds seem softer and more atmospheric.

Continuous Tone. Working on rough-textured paper—such as charcoal paper—you can let your strokes flow together softly so that the viewer doesn't see the individual chalk marks. The technique is to move the chalk lightly back and forth over the paper, never pressing hard enough to let a distinct stroke show. To darken an area, you go over it several times with light strokes so that the granules of chalk pile up very gradually. This technique is easiest on a rough-textured sheet, since the tooth of the paper shaves off and grips the granules of chalk.

Step 1. This demonstration drawing of mountains and evergreens will give you an idea of the variety of marks you can make with a stick of chalk—ranging from slender lines made with the sharp corner to broad strokes made with the squarish end or the flat side. As always, the artist begins with a very simple line drawing, using the sharp corner of the chalk. He draws the silhouettes of the cliffs, which look like irregular squares. He visualizes the cluster of evergreens at the foot of the cliff as a single mass—and he encloses this mass with just a few lines. The cluster of evergreens on the left-hand side of the picture is suggested with a zigzag line.

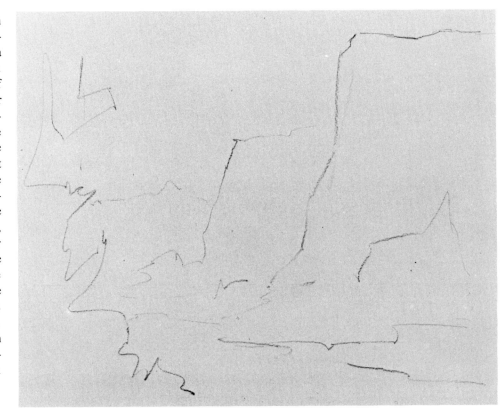

Step 2. Still working with the sharp corner of the chalk, the artist draws the contours of the cliffs more carefully. Along the top and side of the big cliff on the right, he draws a second line to suggest strips of light. At the bases of the rocky shapes, he moves inside the original guidelines to draw shapes that look more like trees, although he still works with just a few casual lines, knowing that they'll soon be covered with heavier strokes of tone. At the extreme left, he adds a rough vertical stroke to suggest a tree trunk that will show more clearly at a later stage of the drawing.

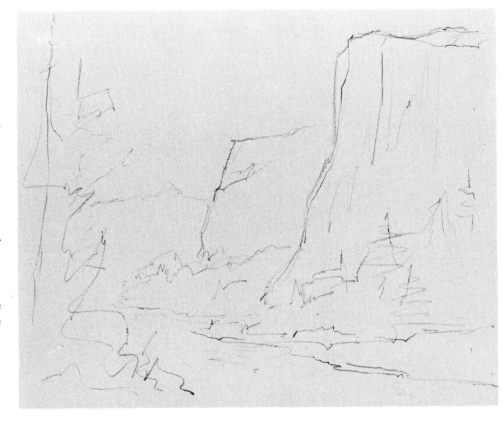

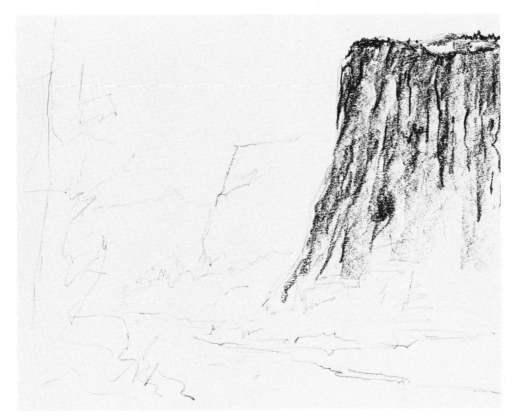

Step 3. With the squarish end of the chalk, the artist begins to block in the shadows on the face of the big cliff. Then, turning the chalk so that the sharp corner touches the paper, he draws deep, dark cracks that run in wavy vertical lines down the cliff. He also begins to sharpen the contours of the top. Although the overall shape of the cliff is more or less square, the rocky forms on its face look like irregular cylinders—on which the artist suggests the gradation from light to shadow to reflected light that you see on cylindrical forms. At the top of the cliff, you can see the patch of light that the artist outlined in Step 2.

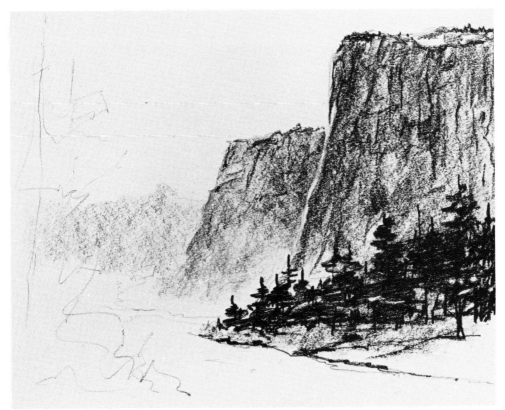

Step 4. The artist picks up a short chunk of broken (or worn-down) chalk. With the flat side of the broken stick, he darkens the big cliff and blocks in broad tones on both the central cliff and the pale mountain in the distance. He uses a sharp corner to draw more cracks. With the squarish end of the stick, he draws the dark foliage with thick horizontal lines. Then he draws slim vertical lines for the trunks with the sharp corner of the chalk. He places a shadow on the shore beneath the trunks with the flat side of the chalk, and then he draws the shoreline with the corner.

Step 5. Pressing more lightly on the square end of the chalk, the artist draws the paler, more distant mass of evergreens, adding a few crisp strokes with the corner of the stick to suggest a few trunks. He also uses the squarish end of the stick to block in the reflections of the evergreens in the water with horizontal strokes. Notice that the reflections are lighter than the trees.

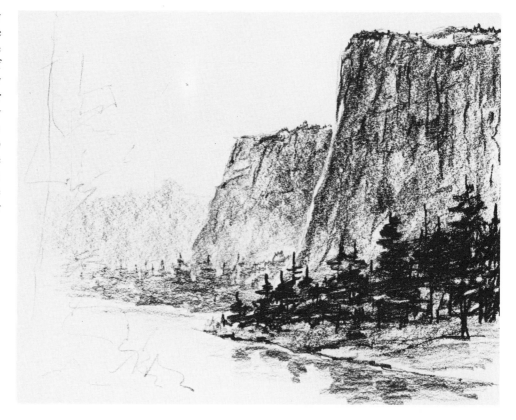

Step 6. As the stick of chalk wears down, its tip becomes blunt and slightly rounded, making a stroke which is thick but no longer squarish. Now the artist draws the dense foliage of the evergreens at the left, making clusters of horizontal and diagonal strokes with the blunt end of the chalk. He leaves spaces between the strokes to suggest the light of the sky breaking through the foliage. Then, working with the sharp corner of a fresh piece of chalk—or sharpening a worn piece on the sandpaper pad—he adds crisp vertical lines to suggest trunks and a few branches.

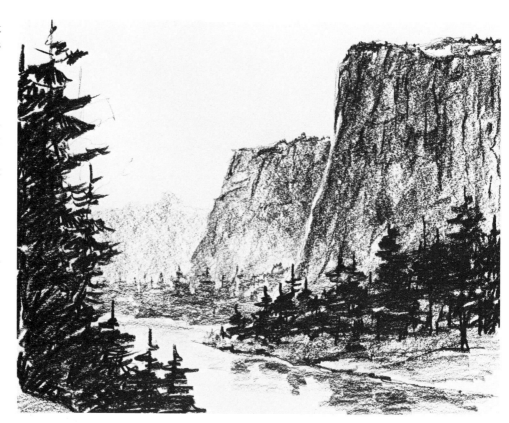

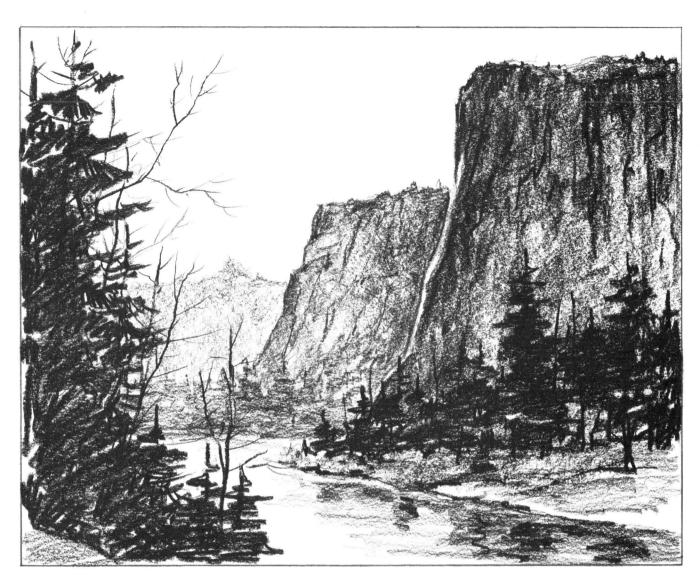

Step 7. In this final stage, the artist goes over all three mountainous shapes with the flat side of a short chunk of chalk, darkening them with broad strokes. With the sharp corner, he adds more cracks to the two nearby mountains, but he remembers the rules of aerial perspective and adds no details to the pale, distant mountain. With the blunt end of a worn stick, he darkens all the trees with a dense layer of horizontal strokes and then darkens the shoreline and reflections on the right in the same way. Heavy zigzag strokes suggest the reflections of a few individual trees in the stream. Finally, the artist sharpens the chalk to a point and adds the precise lines of branches and twigs to the cluster of trees at the extreme left. This part of the picture is closest to the viewer, so that's where the artist concentrates his precise details—remembering the rules of aerial perspective once again.

DEMONSTRATION 6. SURF

Step 1. Like charcoal, chalk lends itself equally well to crisp lines, broad strokes, and blended tones. A seascape, combining the rugged forms of rocks and the softer forms of water, is a good subject for exploring this combination of chalk-drawing techniques. In his preliminary line drawing, the artist draws the hard, distinct shapes of the rocks and the softer, less distinct shapes of the surf and waves with equal care. Although the sea keeps moving, the waves and surf assume repetitive shapes, which the artist studies carefully and then draws quickly with curving lines. Of course, many of these lines will eventually disappear when the tones of the surf are blended.

Step 2. Working over and within the guidelines of Step 1, the artist draws the rocks in more detail. He adds smaller shapes within the big shapes that were defined in the original guidelines. He draws the distant waves more precisely but avoids adding more lines to the soft, curving shape of the foam between the rocks, since this soft shape will be rendered with blended tones rather than lines or strokes.

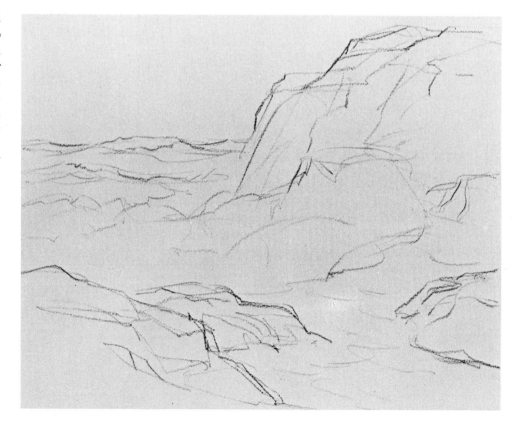

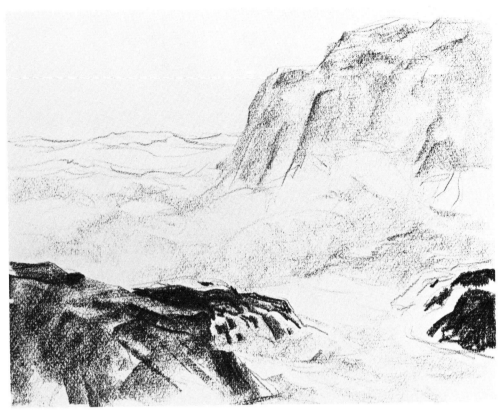

Step 3. Reaching for a short piece of chalk, the artist uses the flat side of the stick to suggest tones on the distant rock formation on the right and to block in the soft, blurry shadows on the surf between the rocks. Pressing harder on the side of the chalk, he begins to block in the darks of the rocks at the left. Then he uses the squarish end of a fresh stick to draw more distinct strokes on both rock formations in the foreground. Here and there, he uses the corner of the stick to add a sharp line. Notice how he leaves areas of bare paper to suggest foam running over the rocks.

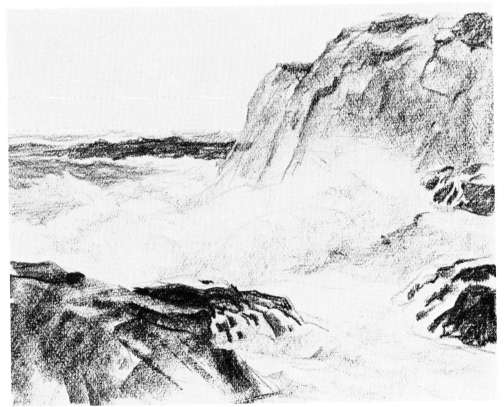

Step 4. With a blunt-ended stick, the artist draws the shadowy faces of the distant waves. Look at the strokes carefully and you'll see that the actual chalk marks are slightly wavy. Irregular strips of bare paper are left for the bands of foam at the crests of the waves. Along the lower edge of the oncoming foam at the center of the picture, the artist uses the side of the chalk to suggest the shadow cast by the wave on the foaming water between the rocks. With the side of the stick, he darkens the big rock formation on the upper right and begins to add some thick, shadowy cracks with the end of the chalk. He also adds another small, dark rock at the extreme right.

Step 5. The blunt end of the chalk is used to darken the side of the rock formation on the upper left with a cluster of parallel strokes. A few more cracks are added. The shadowy sides of the rocks on the lower left are darkened in the same way, so now there's a clear distinction between the lighted top planes and the dark side planes. Short, curving strokes are added to the foreground to suggest foam running down the sides of the rocks and swirling between them. On the right, the artist moves his chalk lightly over the paper to darken the shadow cast by the mass of oncoming foam.

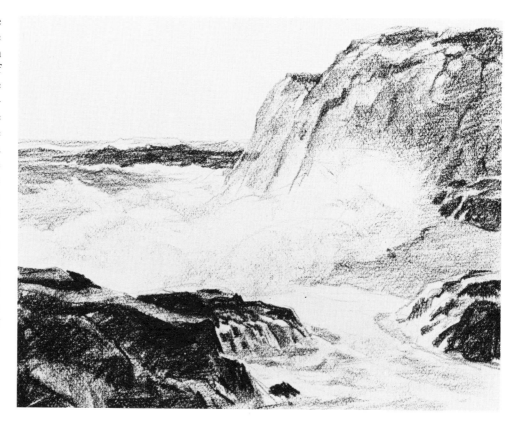

Step 6. The artist moves the flat side of the short chalk along the shadowy face of the foamy mass. Then he blends this tone with a stomp. He also darkens and blends the foamy sea beyond the white mass on the left. In the same way, he darkens and blends the shadow cast by the mass of surf on the right, adding a few dark strokes for detail. He adds some short, curving strokes to the churning foam on the lower right and blends these as well.

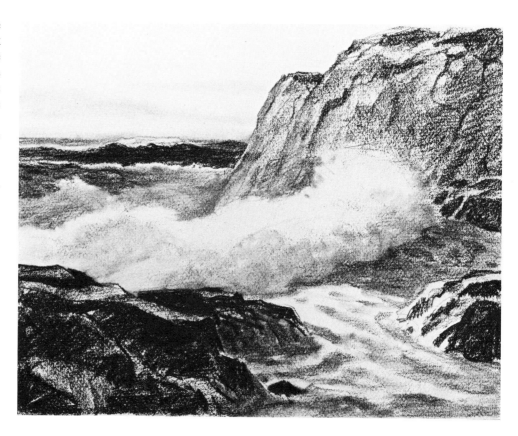

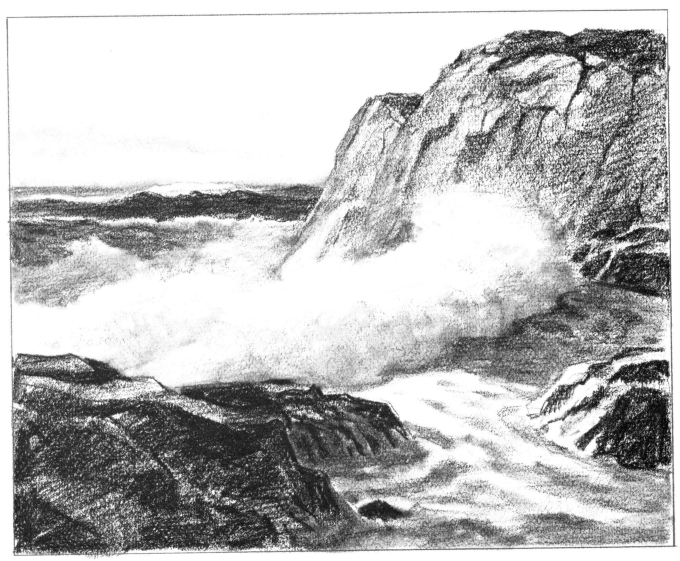

Step 7. As usual, the artist strengthens his tones and adds the last important details at this final stage. He darkens the big rock formation on the upper right by moving the blunt chalk lightly over the paper, and then he adds more cracks and deep shadows with a sharpened stick. With the side of the chalk he adds more tone to the shadowy front of the mass of surf—and to the shadow that the surf casts on the water—blending these tones with short, curving strokes of the stomp. The soft shape of the foam has a clearly defined lighted plane—where the sun strikes the top of the form—and a shadowy side plane. Thus, the foam is as solid and distinct as any other three-dimensional form. The blunt end of the chalk is used to carry long, wavy strokes across the churning foam on the lower right; these strokes are blended with the stomp, leaving gaps of bare paper to suggest sunlight flashing on the white water. The rock formation on the lower right is darkened with another layer of broad, slanted strokes, making these shapes seem still closer to the viewer.

The artist uses the point of the stomp to do just a bit of blending on the distant waves, making their tones seem slightly smoother. The blackened end of the stomp is used like a brush to paint some delicate cloud layers just above the horizon. The sunlit areas of the foam are carefully cleaned with a wad of kneaded rubber that's squeezed to a point to get into the intricate shapes in the lower right. The bare paper of the sunny sky is brightened by pressing the kneaded rubber against the paper and then lifting the eraser away. By now, you've certainly discovered that this drawing is done on a rough-textured sheet of drawing paper. The ragged tooth of the paper roughens the strokes that are used to draw the rocks, thus heightening the rocky texture. At the same time, the irregular surface of the paper softens the strokes of the stomp to produce beautiful, furry tones in the surf and sky. This seascape is a particularly memorable example of the many ways in which chalk can be used in the same drawing.

Step 1. Chalk, like charcoal, blends easily and can be moved around on the drawing paper the way oil paint is moved around on canvas. This atmospheric winter landscape will show you how to make a "black-and-white painting" by blending chalk as if it were wet oil paint. Because the finished drawing will contain many soft, blended tones, the preliminary line drawing is extremely simple. The artist uses the sharp corner of the chalk to draw the silhouettes of the mountain and the tree-covered shore in the distance, as well as the rocky, snow-covered shore of the frozen lake in the foreground. He doesn't indicate individual trees at all, except for a single tree trunk just left of center.

Step 2. Still concentrating on silhouettes, the artist draws the distant mountain and tree-covered shore more carefully, but he doesn't indicate the shape of a single tree in the distance. He draws the shoreline more precisely, adding more rocks and the trunks of a few more trees. But he makes no attempt to define the irregular shapes of the foliage on the trees, since this will be done later with broad strokes of the chalk and the stomp.

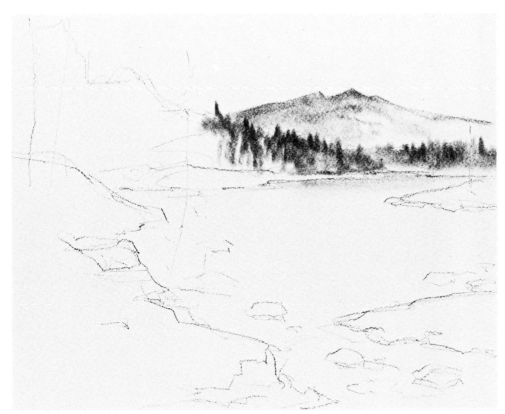

Step 3. Since a feeling of distance is important to this landscape, the artist begins to draw the remote forms of the mountains and the tree-covered shore at the far end of the frozen lake. He moves the blunt end of the chalk lightly over the slopes of the mountain and immediately blends the strokes with a stomp. He begins to draw the distant mass of evergreens with vertical strokes and then blends these tones with vertical strokes of the stomp. The stomp is now covered with black chalk, and so he uses this versatile tool to make additional tree strokes that have a particularly soft, magical quality.

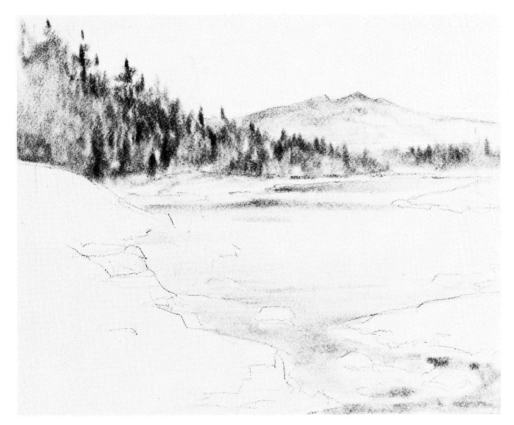

Step 4. Continuing to work on the mass of distant evergreens, the artist alternates short, vertical strokes of the blunt chalk with strokes of the stomp. The stomp blends the chalk strokes and then adds its own special kind of soft strokes. The artist begins to add streaky tones to the icy surface of the frozen lake. He moves the chalk lightly over the paper and then blurs the strokes slightly with touches of the stomp. Now you can see clearly that he's working on a rough sheet of drawing paper that's particularly responsive to blending.

Step 5. Having established the soft, misty tone of the most distant elements of the landscape, the artist begins to add the strong darks to make sure that they contrast properly with the paler tones. In the foreground and middleground, he blocks in the shadow sides of the snow-covered rocks and shore, letting the rough texture of the paper show and leaving the strokes unblended. At the extreme left, he draws the trunk and foliage of a clump of evergreens, again leaving the strokes unblended and allowing the pebbly texture of the paper to suggest the detail of the foliage.

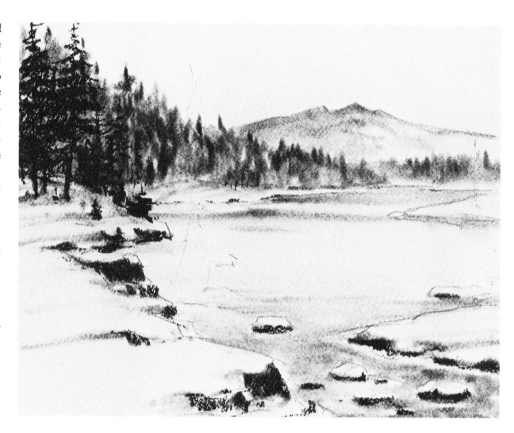

Step 6. Remember the single tree trunk that appeared in Step 1? Now this becomes the focal point of the picture: a dark evergreen that's drawn with clusters of short diagonal strokes to suggest foliage, plus a few slender strokes for the trunk and branches. The artist adds more evergreens on both sides of the lake and leaves the strokes unblended. Now he uses the sandpaper pad and the stomp in a new way. He presses the stomp against the blackened surface of the sandpaper, picks up the dark dust the way a brush would pick up paint, and begins to draw the shadows of the trees across the snowy shore. In the same way, he adds touches of shadow along the edges of the snow banks.

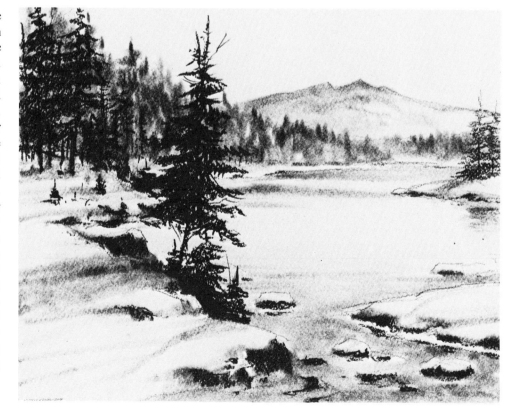

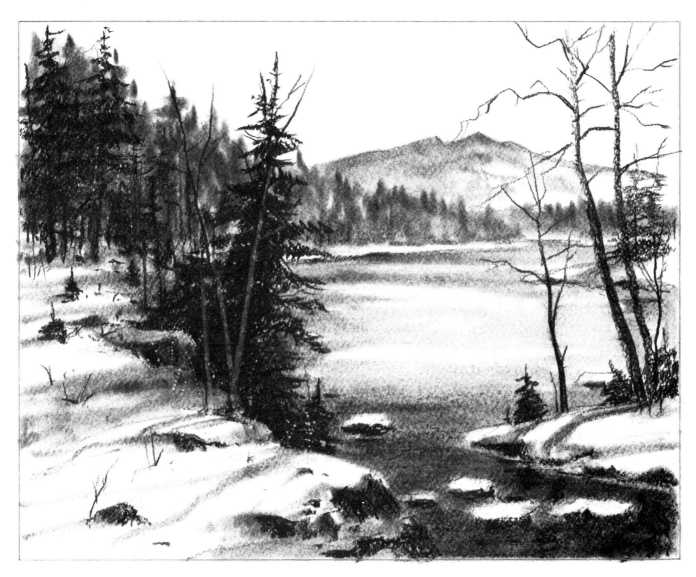

Step 7. All the main elements of the picture have now been placed on the paper. The forms in the foreground, middleground, and distance are all clearly defined. Now the artist can concentrate on enriching his tones and adding detail. He darkens the mountain against the horizon and the mass of evergreens on the distant shore with more strokes of the chalk, which he blends with the stomp. The stomp moves diagonally over the shape of the mountain and vertically over the shapes of the distant trees. The artist glides the squarish end of the chalk lightly across the center of the frozen lake; he applies more pressure to suggest the dark reflections of the trees on the far shore and the reflections of the trees in the immediate foreground. The stomp blends the tones of the lake with long horizontal strokes. The artist darkens the evergreens on the left with a dense network of strokes, pressing hard against the paper and leaving these tones unblended. Then he uses a sharpened stick of chalk to draw more trunks and branches on the left—and adds a whole new group of bare trees on the right. He adds still more evergreens on the low shore at the right. Working with the blunt end of a stick of chalk and the blackened end of the stomp, he draws more lines of shadow across the snow, to indicate shadows cast by the trees. The kneaded rubber moves carefully between the shadows on the snow to brighten the patches of bare paper suggesting sunlight on the shore. The rubber also brightens the tops of the snow-covered rocks in the water and draws pale lines across the center of the lake to suggest sunlight glistening on the ice. The kneaded rubber moves across the sky to pick up any trace of gray that might dim the paper. And finally, the kneaded rubber is squeezed to a sharp point to pick out pale trunks that appear against the dark mass of the evergreens on the left shore.

Strokes on Smooth Paper. The sturdy white drawing paper (called cartridge paper in Britain) that's sold in every art-supply store is equally good for drawing in pencil, chalk, and charcoal. Here's a drawing that's made with a medium-grade charcoal pencil on ordinary drawing paper. The sheet has a very slight texture that you can see if you look closely at the strokes, but the marks of the charcoal pencil are sharp and distinct.

Strokes on Rough Paper. As its name suggests, charcoal paper is made specifically for drawing in charcoal—though many artists like it just as well for chalk and graphite pencil. In this drawing of the same subject shown at your left, the strokes show the distinct, ribbed texture of the paper. It's worthwhile to try charcoal paper because you may like the way it breaks up and enlivens your lines and strokes. The surface is also excellent for blending.

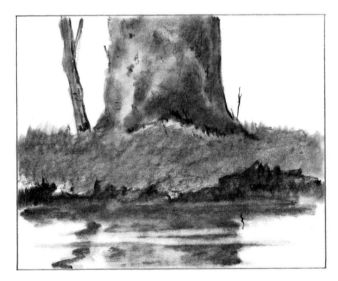

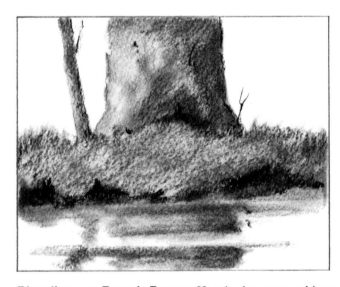

Blending on Smooth Paper. When you blend charcoal strokes on the usual white drawing paper, you get soft, furry gradations that don't show much of the texture of the sheet. In this close-up of a section of a larger landscape, nearly all the charcoal strokes have been blended, but you don't see much evidence of the paper surface. There's a bit of roughness in the grass, but this is produced by the charcoal strokes themselves, which are only partially blended. In the tree trunk and its reflection, the strokes have been blended away to produce smooth, even tones.

Blending on Rough Paper. Here's the same subject drawn on rough paper and blended. Now the ragged texture of the paper is obvious. A charcoal drawing on rough paper—whether the strokes are blended or left alone—has a bold, irregular look. Tonal gradations can be just as subtle as they are on smooth paper, but the tones usually have the broken, pebbly quality you see here. Buy several different kinds of paper, smooth and rough, to discover which surfaces you like best for charcoal drawing.

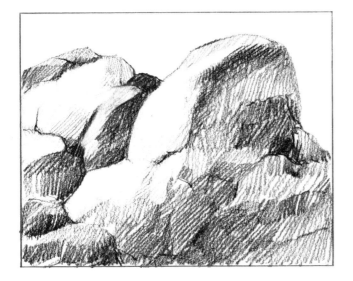

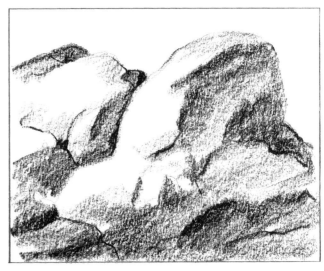

Slender Strokes. People generally think of charcoal as a medium for rough strokes and rich tonal effects. But a sharpened charcoal pencil—or even a sharpened stick of charcoal—can produce slender, expressive lines. In this section of a rocky landscape, the tones are rendered with clusters of parallel lines. Several layers of lines overlap to produce darker tones. And if the tones become too dark in some area, they're easily lightened by pressing a wad of kneaded rubber against the paper—as you see in the sunlit planes of the rocks.

Broad Strokes. This drawing of the same rocks displays the broad strokes that are typical of the way most people use charcoal. The preliminary outline drawing is made with slender lines, but then the tones are rendered with broad strokes of the side of the pencil or charcoal stick. Darker tones are produced simply by pressing harder on the charcoal or by going over the same area several times. Charcoal smudges easily, but the artist leaves the drawing unblended, recognizing that his rough strokes produce a rugged, rocky feeling.

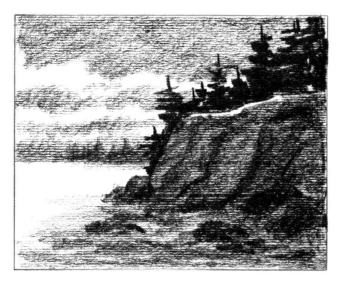

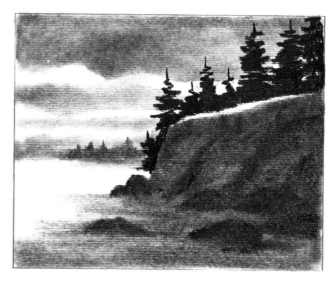

Building Tone with Strokes. On the ribbed surface of charcoal paper, you can build a rich tonal effect entirely with strokes—without blending. As you move the charcoal pencil or the charcoal stick lightly back and forth over the sheet, the tooth of the paper gradually collects the black granules. With each stroke, you build up more tone. In this section of a landscape drawn at sunset, the mark of the drawing tool is obvious only in the trees, which have been drawn with firm, heavy strokes. The rest of the picture has been built up gradually by laying one soft stroke over another.

Building Tone by Blending. What many artists love about charcoal is its soft, crumbly quality, which makes the strokes easy to blend with a fingertip or stomp. Here, the same subject has been drawn on charcoal paper with strokes of soft natural charcoal, blended so that the strokes disappear and become rich, smoky tones. Kneaded rubber brings back the whiteness of the paper, as you see in the sky, the water, and the bright top of the cliff. The trees are drawn with firm, dark strokes and left unblended.

Step 1. To test out the different kinds of lines and strokes you can make with charcoal, find a subject that has a lot of texture and detail, such as a densely wooded landscape. Get yourself several charcoal pencils—hard, medium, and soft. The artist starts this demonstration by drawing the contours of the tree trunks with the sharpened point of a hard charcoal pencil. He defines the path through the woods with a few wavy lines but makes no attempt to draw the contours of the leafy masses, which are so scattered that they have no distinct shape. Later, he will draw the clusters of leaves with clusters of strokes.

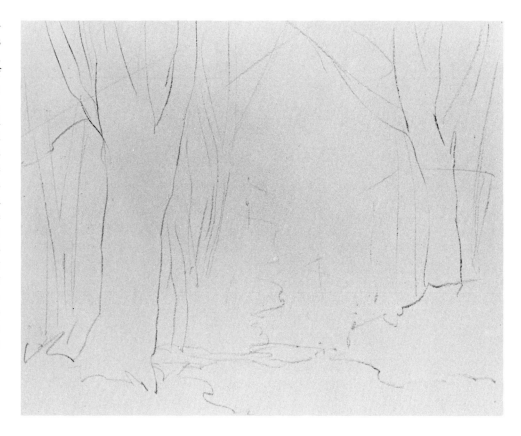

Step 2. Because he wants to create a sense of distance between the dark shapes of the trees in the foreground and the pale, distant trees, the artist begins with the remote tone of the evergreens that appear far off, seen through the opening in the forest. Resting the side of the lead lightly on the paper—which is just ordinary drawing paper—the artist moves the hard charcoal pencil from side to side with an erratic, scribbling motion. The forms of the trees are gradually built up by laying one light stroke over another. The artist presses harder on the pencil when he draws the darker trees on the left.

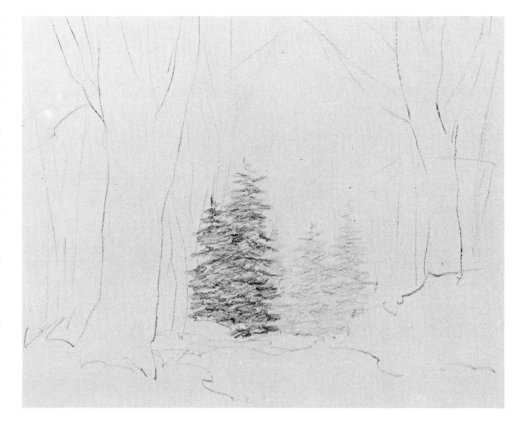

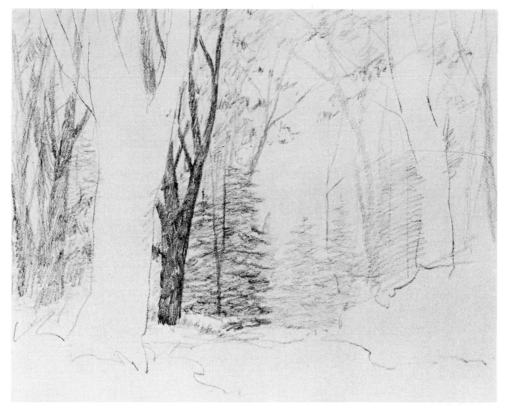

Step 3. Still working with the hard charcoal pencil, the artist begins to work on the tree trunks that are just beyond the big trees in the foreground. Pressing somewhat harder on the pencil, he builds the tone of a darker tree and branches with clusters of parallel strokes. He lets the strokes show to suggest the bark. On the left, he draws paler, more distant trunks and branches in the same way. To the right of the gap in the forest, he suggests shadowy tones and the pale silhouettes of tree trunks with groups of slanted strokes. Toward the top of the picture, the artist begins to suggest sparse foliage with scattered groups of small, scribbly strokes.

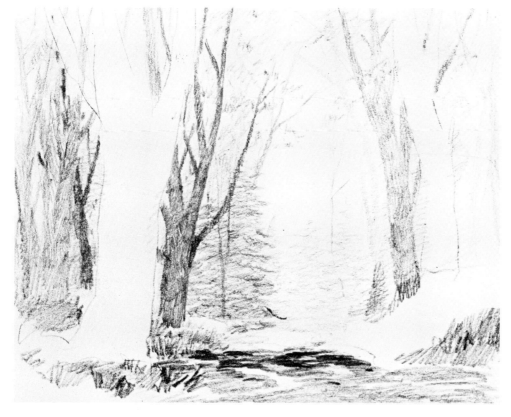

Step 4. On either side of the picture, the artist adds slightly darker trunks with clusters of strokes, still using the hard pencil. Now he moves into the foreground, covering the woodland path with groups of horizontal strokes, and leaving gaps of bare paper to suggest sunlight on the path. He suggests a shadow across the path by pressing harder on the pencil. Clusters of scribbly, slanted strokes indicate the undergrowth. The direction of the strokes varies with the subject: horizontal strokes for the ground; vertical ones for the tree trunks; and slanted strokes, leaning in various directions, for the grasses and weeds.

Step 5. To add darker tones to the foreground, the artist reaches for the medium charcoal pencil. He builds up the clumps of grasses and weeds with groups of spiky, irregular strokes that point erratically in various directions, as the subject does. At the left, he adds touches of dark shadow among the trees. And then he introduces a big, darker trunk and branches at the extreme right, again working with overlapping groups of parallel strokes that suggest the texture of the bark. Around the dark tree, he adds some slender strokes for smaller, younger trees. The grassy strokes beneath the tree are darkened to suggest its shadow.

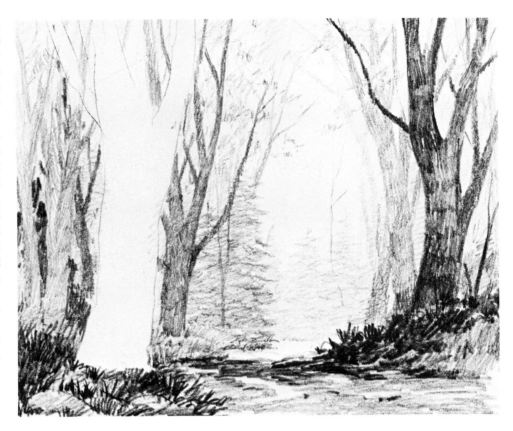

Step 6. The artist uses the flattened tip of the medium pencil to draw the rough, dark shape of the big tree at the left. The clusters of strokes are large and distinct, so that the ragged texture of the bark is obvious. The artist piles stroke upon stroke to darken the branches that reach out from the main trunk—particularly the branch that arches across the center of the picture. Around the big branch, the artist dashes in small, dark strokes with the blunt tip of the pencil to create leaves. In the distance, the hard pencil is used in the same way to suggest paler clusters of leaves. The hard pencil also adds slender trunks and branches in the distance.

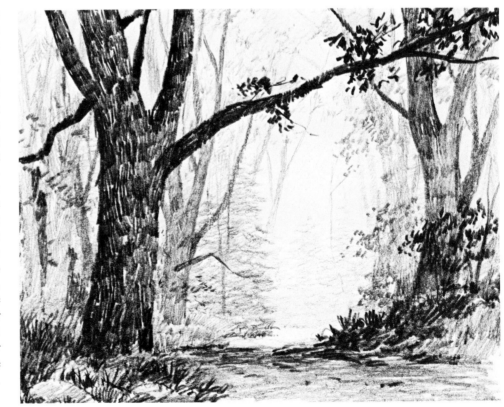

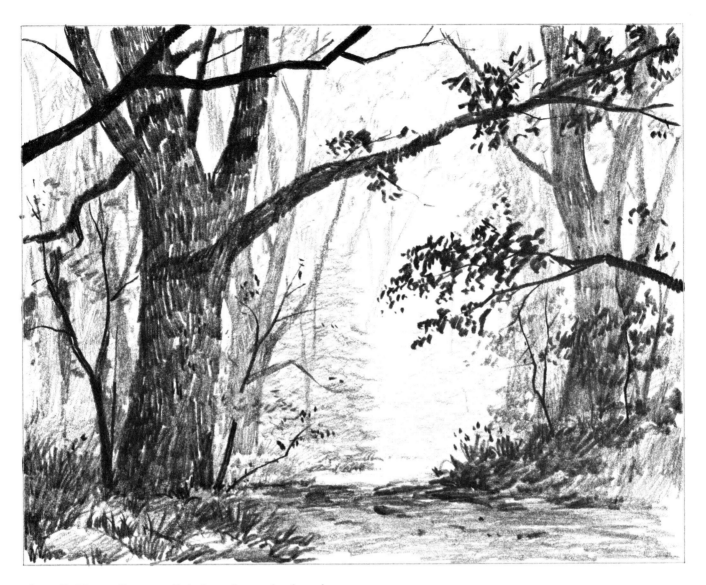

Step 7. The medium pencil darkens the trunks, branches, and foliage of the distant trees, adding small, scattered strokes to suggest more foliage. The trunk and branches of the big tree on the right are darkened with vertical strokes. Strokes are added to the clumps of weeds and grasses on either side of the forest path, so now the growth seems dense and shadowy. Another layer of horizontal strokes is scribbled across the path itself to accentuate the contrast between the shadowy section of the path in the foreground and the sunlit patch in the distance. The deep, dark tone of the soft charcoal pencil is saved for the very end. Now the pencil is sharpened and brought in to add the rich blacks of additional trunks, branches, and foliage on both sides of the picture. The sharpened point of the medium charcoal pencil adds the more delicate lines of the twigs. Study the many different ways in which the charcoal pencil is used to render the varied textures, tones, and details of this complex drawing. And notice that all the subtle effects of light and atmosphere are created entirely with lines and strokes.

Step 1. Now look for a landscape subject that will give you an opportunity to combine slender lines, broad strokes, and smudged tones. For this demonstration, the artist chooses a pond surrounded by trees and rocks. This preliminary line drawing, made with a hard charcoal pencil, simply defines the group of tree trunks on the right, the rocky shorelines across the center of the picture, and the soft shapes of the trees on the far shore. The artist makes no attempt to draw the details of the light and shadow in the water, which he'll block in with broad tones in the next step.

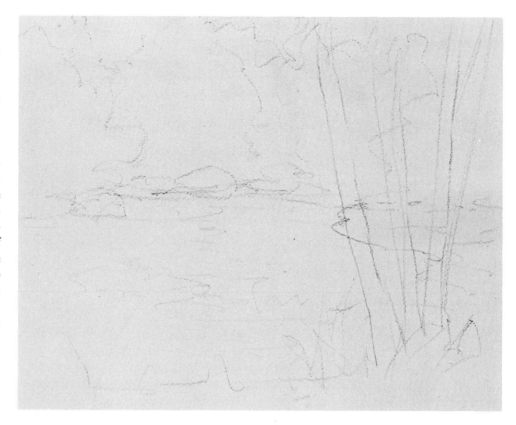

Step 2. The artist has chosen a rough sheet of paper whose texture will suggest the details of foliage and also permit him to do a lot of blending. Working with the side of a medium charcoal pencil, he blocks in the tones of the mass of trees on the far shore, building stroke upon stroke to darken the shadow areas. He also blocks in the shadowy sides of the rocks. Then he begins to draw the dark reflections of the trees in the water, using long horizontal strokes. He blends all these tones lightly with a fingertip but doesn't rub hard enough to obliterate the strokes. He brightens the sunlit tops of the rocks with the kneaded rubber eraser.

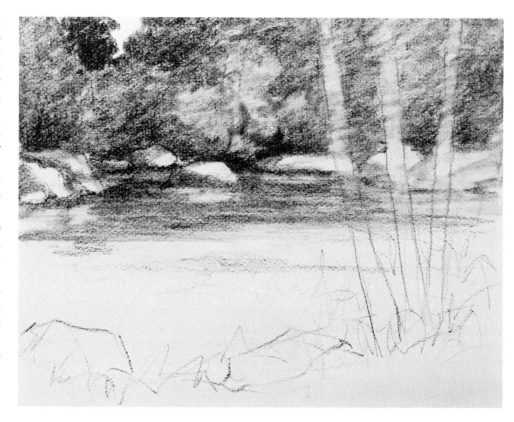

Step 3. Working with the medium charcoal pencil, he blocks in the darks among the distant trees—and their reflections in the water—with short, curving strokes that suggest the character of foliage. He doesn't blend these strokes but allows them to stand out, dark and distinct among the gray tones that appeared in Step 2. He uses the kneaded rubber to lighten some clusters of foliage and suggest patches of sunlight among the trees.

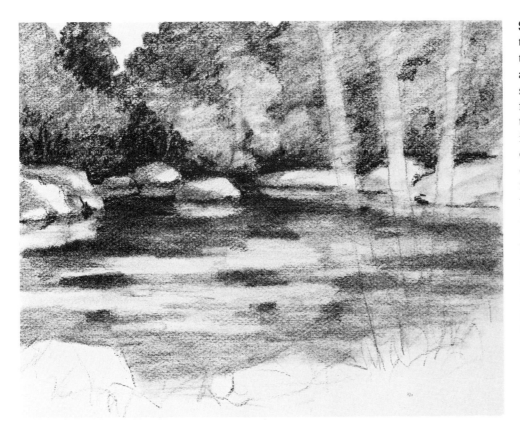

Step 4. Moving down across the water, the artist continues to block in the pattern of light and dark with horizontal strokes. Next he moves his fingertip horizontally across the paper to turn the strokes into subtle, smoky tones. He carries patches of darkness down into the water, suggesting more reflections of the trees on the distant shore. And he wipes away streaks of sunlight on the water with a kneaded rubber eraser. Notice that the lines of the three tree trunks on the right are almost obliterated. But this is no problem; the trees will soon reappear.

Step 5. The artist sharpens the medium pencil on the sandpaper block to draw the crisp, dark detail of the foreground. He fills the dark shapes of the three tree trunks with clusters of parallel strokes, leaving an occasional gap to suggest a flicker of light on the rough bark. The pencil has become blunt once again, which is perfect for making short, thick strokes that suggest foliage at the top of the dark trees. Delicate touches of a sharp, hard pencil suggest the floating lily pads with elliptical lines.

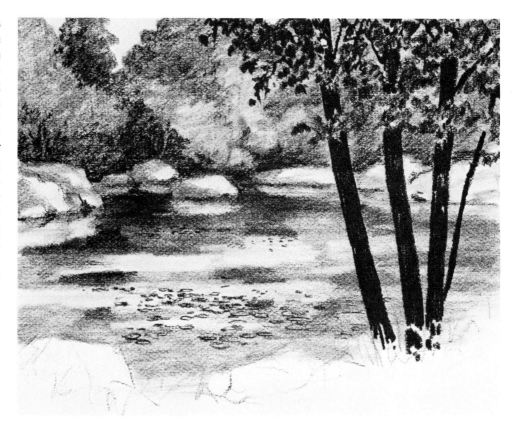

Step 6. The artist covers the ground with broad, rough strokes and blends them lightly with a fingertip. Now the rocks have a blocky, dark silhouette. Sharpening the point once again, he draws the graceful lines of the foreground weeds with arclike movements of the pencil.

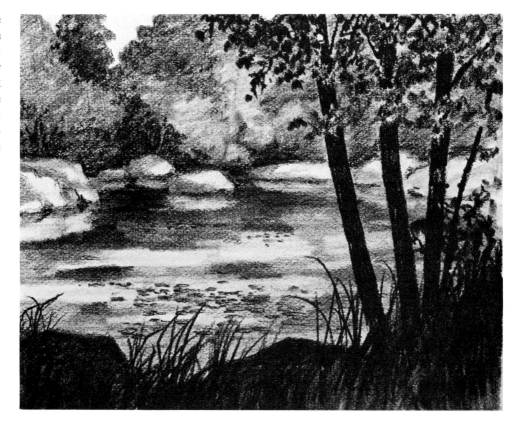

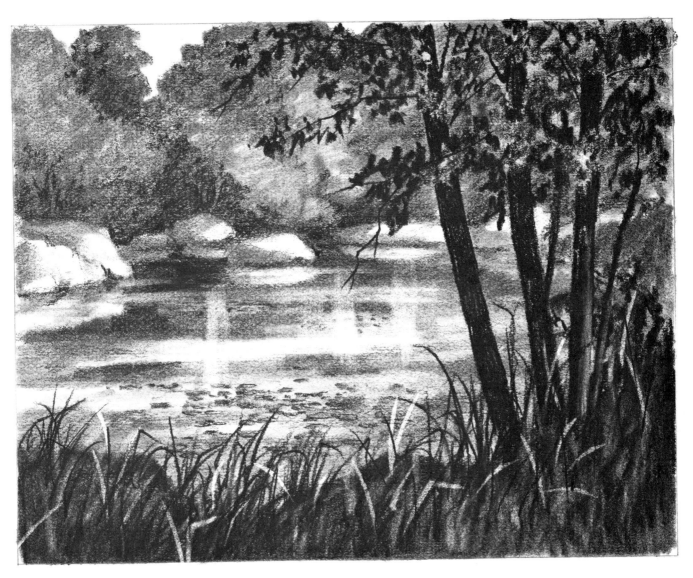

Step 7. Picking up a soft charcoal pencil, the artist moves it lightly over the mass of trees on the far shore and blends the strokes softly with a fingertip to darken the entire area. He then uses his charcoal-covered fingertip to darken the shadows on the rock and the shadowy patches in the water. (If he runs out of charcoal on his fingertip, he can easily blacken his finger again by pressing it against the blackened sandpaper pad.) The tip of the medium charcoal pencil adds more foliage in the upper right with quick, scribbly strokes. The sharp point of the pencil adds more twigs and branches, and then moves down to add more grasses and weeds to the foreground. To strengthen the contrast between light and shadow, the kneaded rubber eraser comes into play. It's squeezed to a sharp point to clean jagged patches of sky and the sunlit areas of the rocks. Then the eraser is moved very lightly across the water—horizontally and then vertically—to add splashes of light on the shadowy surface of the pond. The eraser creates a flash of sunlight on one tree trunk at the extreme right. Squeezing the eraser to a sharp point, the artist picks out some pale lines among the foreground grasses to suggest blades caught in sunlight. Throughout the drawing, the rough texture of the paper adds boldness to the strokes, suggests detail among the distant clumps of foliage, and adds vitality to all the blended tones.

Step 1. For blended tones—with subtle gradations from deep blacks to misty grays—no medium compares with natural charcoal. To demonstrate the beauty of this simplest of all drawing mediums, the artist chooses the soft lights and shadows of dunes on a beach, with a brooding sky overhead. Sharpening a stick of natural charcoal on a sandpaper pad, the artist draws the silhouettes of two big dunes, suggesting patches of beach grass at the top of each dune. He draws a horizontal line for the horizon of the sea in the distance.

Step 2. The blended tones of natural charcoal are particularly beautiful on rough paper, and so the artist has chosen a sheet with a distinct tooth. He blocks in the dark clouds with broad strokes and then blends these strokes with a fingertip, moving his finger across the paper with a wavy motion that suggests the movement of the clouds. He uses his charcoal-covered finger like a brush to add veils of pale gray over the lighter areas of the sky. The dark, inverted triangle of sea, glimpsed between the dunes, is drawn with firm, dark strokes and blended slightly with a quick touch of the finger.

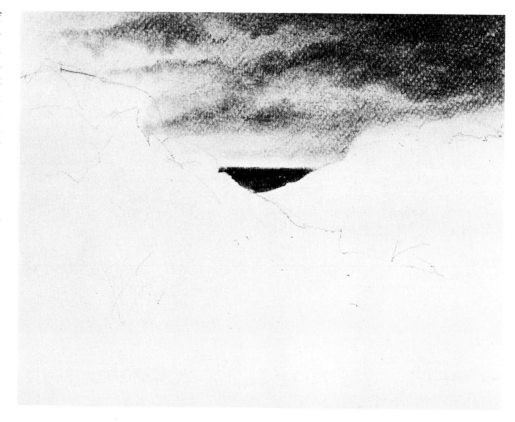

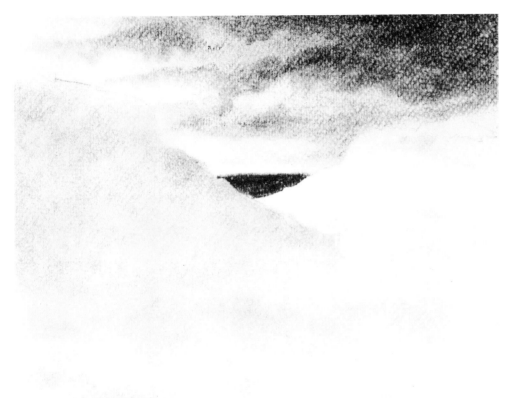

Step 3. The big dune on the left is covered with a soft veil of tone. This is done by passing the side of the charcoal stick very lightly over the paper, applying practically no pressure on the stick, but simply letting it glide over the sheet and deposit the lightest possible strokes. Then the artist moves his finger gently over the paper, softly merging the pale strokes into a misty, continuous tone. The strokes disappear altogether and become a delicate, transparent shadow. To suggest pale shadows on the sandy foreground, the artist touches the paper lightly with his charcoal-covered fingertip.

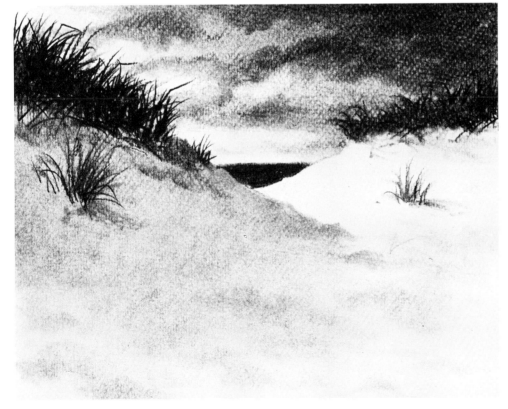

Step 4. Leaving the smaller, more distant dune untouched by the charcoal, the artist allows the bare paper to suggest brilliant sunlight on the sand. Now he scribbles a dark tone at the top of each dune and blends it with his finger to make a smoky blur. Over this blur, he draws dark strokes of beach grass with the sharpened tip of the charcoal stick. Notice that some of the grassy lines curve, while others are spiky diagonals. The artist changes the direction of his strokes for variety. Smaller clusters of beach grass are drawn on the sides of the dunes in the same way. A single sweep of a blackened fingertip suggests shadows at the bases of the clumps of beach grass.

Step 5. Quick, spontaneous touches of the sharpened charcoal stick suggest smaller plants and bits of debris below the clumps of beach grass. Another cluster of beach grass is added at the center of the picture and then slightly blurred with a touch of the fingertip, which creates a shadow. The artist presses his finger against the blackened sandpaper pad to pick up more tone. His finger spreads blobs of tone across the foreground to indicate shadowy curves and irregularities in the beach. Between the dark strokes made by his fingertip, the artist brightens patches of sand with the eraser, suggesting splashes of sunlight.

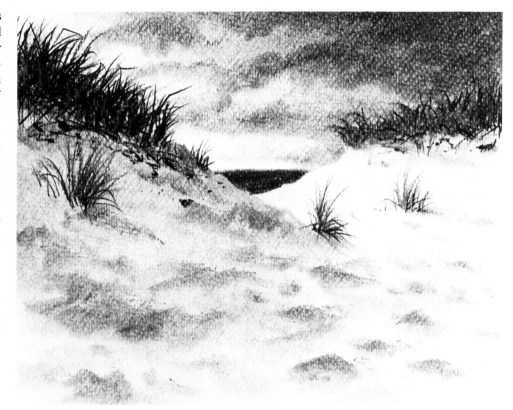

Step 6. Again sharpening the charcoal stick on the sandpaper pad, the artist adds a big clump of beach grass in the foreground. Then, turning the stick on its side, he draws long shadows slanting downward toward the right. He leaves these shadow strokes unblended. Now the charcoal stick moves across the beach, adding blades of beach grass here and there, plus touches to suggest the usual shoreline debris. Except for the shadows cast by the beach grass, the dune at the right remains bare white paper. Surrounded by so much tone, this patch of white paper radiates sunlight.

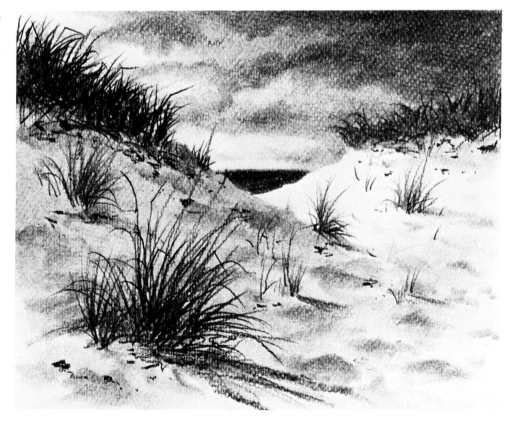

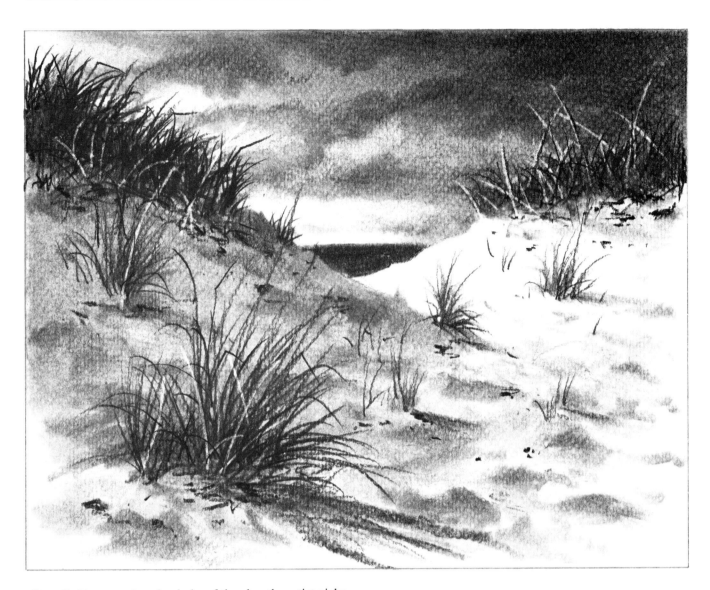

Step 7. To strengthen the darks of the sky, the artist picks up more charcoal dust on his fingertip and softly blends this into the clouds. Working very carefully, he performs the same delicate operation on some of the shadowy areas of the big dune on the left. He adds a few more touches of shadow to the foreground with his finger. To indicate that some of the stalks of beach grass are caught in the bright sunlight, he squeezes the kneaded rubber eraser to a sharp point and picks out slender lines among the clusters of darker strokes. Working carefully with the tip of his little finger, the artist blends the dark, inverted triangle of the sea to make it look smoother and darker; now it contrasts even more dramatically with the sunlit edge of the dune at the right. The kneaded rubber takes a final tour around the drawing, looking for areas of bare paper that have accidentally accumulated a hint of gray from the side of the artist's hand. It's easy to lift tones from the hard surface of the rough paper, so the artist brightens not only the sunlit areas of the dunes but also the strip of sky just above the dark sea. The finished drawing is a dramatic example of the versatility of natural charcoal, which can create everything from soft, smoky tones to crisp, expressive lines.

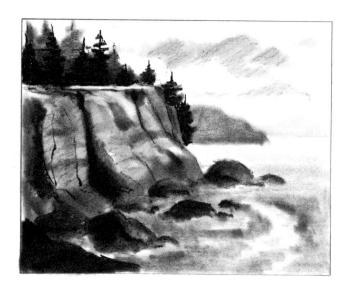

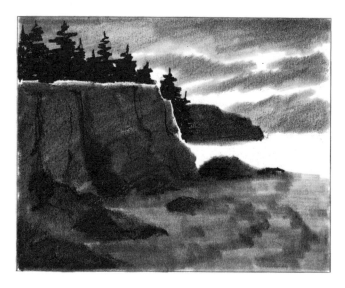

Headland in Three-quarter Light. As the sun moves across the sky, the direction of the light keeps changing; you must work quickly to capture the specific light effect you set out to draw. Here's a headland in three-quarter light, which means that the sun is striking the subject at an angle from above and slightly to one side. On each form, there's a lighted plane on one side and a shadow plane on the other side. Notice the lighted faces of the rocky forms and the shadowy sides. Three-quarter lighting makes the subject look solid and three-dimensional.

Headland in Back Light. Early in the morning and late in the afternoon, the sun is low in the sky and *behind* the shapes of the landscape. This effect is called back light. The fronts of the forms—facing you—tend to be in shadow because the sun hits them from the back. There's often a delicate rim of light around the edges of the shadowy forms. This type of lighting creates strong, dark silhouettes. Many landscape artists treasure this romantic type of lighting and get to work early in the morning to capture the effect before the sun is high in the sky.

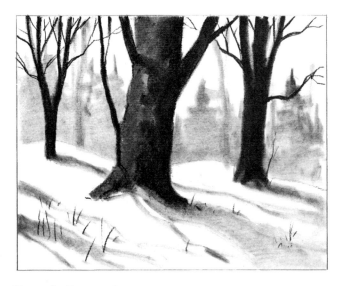

Trees in Strong Sunlight. On a bright, sunny day, you'll find strong contrasts between the tones of the landscape. In this winter landscape, the sun shines brightly on the snow, which contrasts strongly with the dark tree trunks and the slender shadows that the trees cast on the snow. The distant evergreens are paler than the dark trunks in the foreground, but there's still a distinct contrast between their shadowy shapes and the sunlit sky above.

Trees on an Overcast Day. That same subject will change radically on an overcast day, when the sun is hidden behind a layer of clouds. The dark tree trunks grow much paler and there's less contrast between the trees and the snow. The trees cast little or no shadow on the snow, since the sunlight is diffused. The distant mass of evergreens seems to melt away softly into the pale sky. A sunny day and an overcast day are *equally* promising times to draw landscapes. You can go back to the same subject again and again, discovering new magic with every change in the light and weather.